ANGLING IN ART

ANGLING IN ART

TOM QUINN

Foreword by
SIR MICHAEL HORDERN

• THE •
SPORTSMAN'S
PRESS
LONDON

Published by The Sportsman's Press 1991
© Tom Quinn 1991

A catalogue record for this book is available from the British Library

ISBN 0-948253-55-X

Printed in Great Britain by
BAS Printers Limited, Over Wallop, Hampshire

CONTENTS

ACKNOWLEDGEMENTS

Dozens of people helped with my research for *Angling in Art* and although numerous they are not too numerous to mention by name. First I would like to thank the artists, living and dead, whose work forms the real interest of the book but without a large number of extraordinarily helpful individuals, institutions and galleries it would never have got off the ground.

I would like particularly to thank Christie's, Sotheby's, the British Library, Frost and Reed, the National Gallery, St Andrew's University Library, Helen Gazeley and the Burlington Gallery, Ackermann's, the Tryon Gallery, Phillips, the National Gallery of Washington, Brasenose College Oxford, the Henry Brett Galleries, Bonhams, W.H. Patterson Fine Arts, the Tate Gallery, Charles Glazebrook, The Royal Society of Portrait Painters, the Federation of British Artists, Dulwich Picture Gallery, Malcolm Innes Gallery, Glasgow City Art Gallery, Birmingham City Art Gallery, the Eaton Gallery, the Mall Galleries, the IGFA, Melanie Trace, Sandy Leventon, Virgil Pomfrey, David Wootton, Jane Harris, Farlows of Pall Mall, Tom Williams of the Piscatorial Society, The Flyfishers Club, Clandon Park and the National Trust, Laraine Plummer and my good friend John Charles Green.

Particular thanks to those galleries and individuals who, aware of the difficulties of publishing a book like this, gave their permission for pictures to be reproduced without charge. And to Debbie Fischer, who patiently sorted out my execrable typescript, a special thank you.

LIST OF COLOUR PLATES

FOREWORD BY SIR MICHAEL HORDERN

All those pictures you wish you had on your walls – well, here they are, century by century; pictures that have delighted us over the years. What a treasure this volume really is: that party of monks fishing, those top hats, those beautifully lean, eighteenth century trousers so unlike our own.

And the glorious pictures of the days when there was water in our rivers; and truly wild fish and great salmon and pike being played toward what look to me woefully inadequate Victorian landing nets.

I cannot set myself up as an art critic, but I have been a passionate angler since the age of five and such pictures as these have fuelled my enthusiasm over more than three-quarters of a century. They still stir me as no photograph can.

Notice the intense look of pleasure on the faces of the children, innocently intent as they peer into the water over their home-made tackle; notice, too, the figures in George Morland's *A Party Angling*. They may be adults but, like the children, they are clearly entranced by their fishing.

Open this splendid book anywhere and you will be most generously rewarded.

Michael Hordern

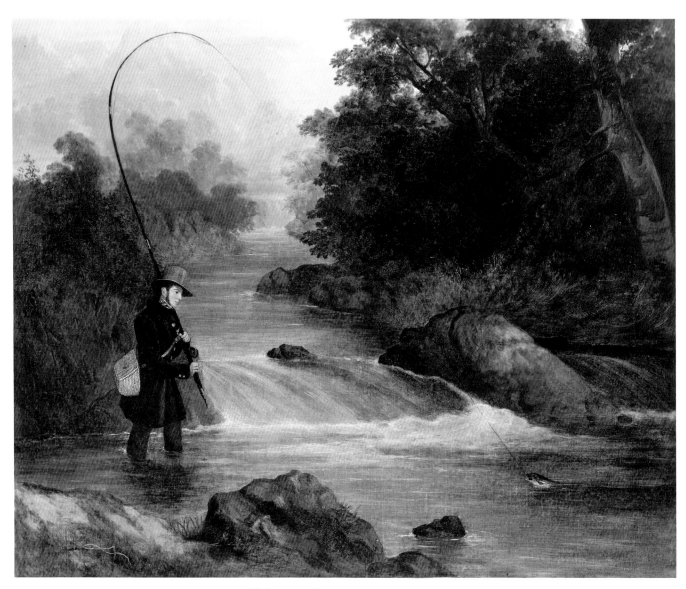

Philip Reinagle, *An angler playing a fish*.

Angling may be said to be so like the mathematics,
that it can never be fully learnt
ISAAK WALTON

1

INTRODUCTION

Angling is almost as old as mankind. There is evidence that our Palaeolithic ancestors fashioned crude hooks to catch fish and the Egyptians, Greeks and Romans certainly fished with rod and line. Much as these early anglers may have enjoyed catching fish they differ in one fundamental respect from the typical angler of more recent times. The difference is essentially one not of intent but of attitude: the intention has always been to catch fish, but for the modern angler it is an enjoyable sport not part of his struggle to survive. The modern angler, in a sense, lives to fish. His ancient brother fished to live. Thus while the anglers of old would have done almost anything to increase the rate at which they were able to catch fish by rod and line, the modern angler turns the thing on its head and tries to make the pursuit of the fish as difficult, within limits, as possible.

On most trout fisheries in England you are likely to catch far more fish on most days using a worm on your hook rather than an artificial fly, but the fly adds to an ancient practical pursuit a special art or artifice. It is an artifice based on the idea that there is more satisfaction to be gained from doing something well than simply from doing it. This is where the modern angler differs so markedly from the ancient and it was the conception of angling as a fascinating pursuit in its own right (rather than for any food it might provide) which made it a subject of increasing interest to the artist.

Isaak Walton's *Compleat Angler* (1653) was certainly the first book in English to give angling a special, poetic charm. Walton instigated and encouraged the idea that anglers were a breed apart and invested the sport with a noble quality that lifted it out of the commonplace. And Walton had an eye for angling in art: he describes 'a

great trout that is near an ell long and its portrait painted and hanging at The George at Ware in Hertfordshire.'

With the rise of the landed class in eighteenth-century England, portraiture became big business and the gentry and middle classes demanded portraits of themselves and their families in a setting that indicated their attachment to noble pursuits and to the land. Certain pastimes, notably racing, shooting and, increasingly, angling became symbols for the leisured classes.

No-one is going to argue that angling is a sport that has captivated artists to the extent that horse racing or hunting has, but from the eighteenth century on, in England at least, angling began to be part of a world of leisured living.

These were early days, but the idea of the English sporting gentleman is very much a product of the eighteenth century. The attachment of the wealthy and the aristocratic – who have always been important patrons of the arts – to their sports inevitably led to the development of sporting art as an almost distinct branch of painting, sculpture and engraving.

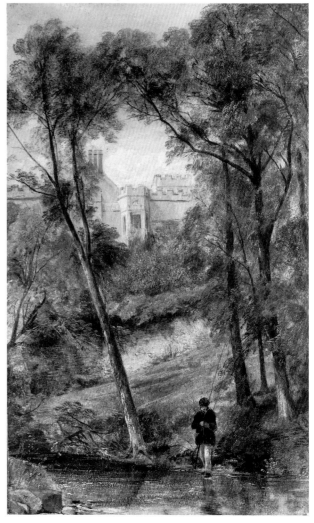

Angling has always been the poor relation so far as sporting art is concerned, but in the twentieth century, as angling has increased in popularity (until it is said to be the biggest participant sport in the United Kingdom) this situation has changed somewhat and angling art is able to hold its own against all-comers.

Thomas Creswick, *Angler fishing in the grounds of Haddon Hall.*

A pre-Inca fishing scene, from around 200 BC.

I have attempted to trace the history of angling in art from its earliest manifestations in Egyptian, Greek and Chinese art, through the great days of sporting art in England in the eighteenth century into the prolific twentieth century. Few artists specialised exclusively in angling and fish paintings, but there are examples of such specialists, particularly among the Victorians, and to these artists I have paid special attention. Many whose work appears in this book may have painted one or two pictures only involving anglers, but where a picture in this category is particularly interesting or important I have included it – together with mention of the artist concerned – in order to give the book as comprehensive a feel as possible.

But I hope readers will enjoy accounts of artists – some in the first rank – who loved angling and tried to paint it not as an incidental feature of a landscape, a portrait or whatever, but as the centrepiece of the picture. The work of many painters in this category – like the great Victorian Leonidas Rolfe – are much sought after by collectors, but little is known of the painters themselves. Others, like Turner, are well known, but not for their creative interest in angling.

I hope *Angling in Art* will not be seen merely as a book of reference because although this is an important part of what it sets out to do, I believe it also makes a convincing argument for angling in art as peculiarly English (and latterly American) and particularly interesting. I have tried to keep this account as straightforward as possible because the larger themes of art criticism do not apply when one is dealing with such a narrow subject area. Most books totally ignore angling in art and they may even discuss a landscape whose only human interest is an angler without mentioning the fact that an angler is there at all! Walter Shaw Sparrow's marvellously discursive *Angling in*

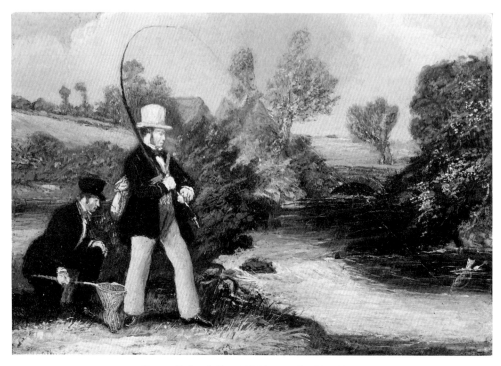

James Pollard, *Trout Fishing on the River Lee*.

H.L. Rolfe, *Fish on the Banks of the Thames*, 1877.

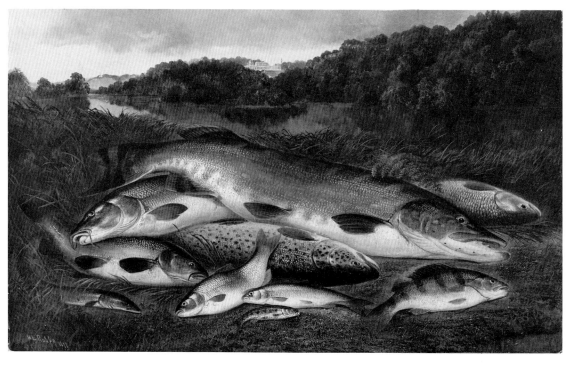

British Art, though a splendid attempt to discuss the subject, often soars so high above it that it is difficult to know what he is talking about. Other accounts of sporting art mention angling very briefly or not at all. And even an authoritative book like Graham Reynolds' *Victorian Painting* makes no mention of angling or fish subjects.

Angling does have a place in art, but like sporting art in general it is important to remember that it is essentially small-scale. This should in no way diminish our interest in how its development and treatment has changed over the centuries, but we have to keep the thing in perspective. As with all sporting art, Britain (and more recently the USA) has produced far more examples of angling in art than other countries where the tradition of angling as a sport simply does not exist. Thus though this book includes angling in the art of ancient civilisations, by the time we reach the eighteenth century the focus has narrowed more or less to the United Kingdom. The development of angling in art in America has a chapter to itself.

It is important to remember that there is no shortage of artists who have tried their hand at painting the subject. The number includes many major figures, but there are also dozens whose lives are lost in the obscurity of history, but whose work remains for us to enjoy.

An illustration by Arthur Rackham for *The Compleat Angler*.

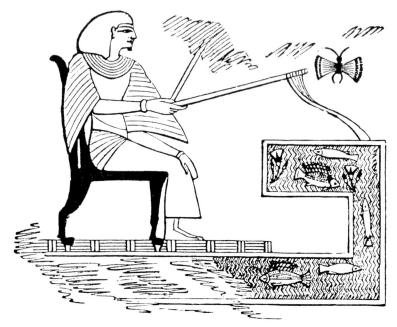

One of the oldest representations of angling, *c* 1400 BC.

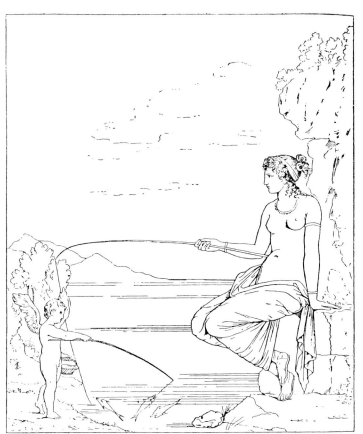

Venus and Cupid Angling from the *Real Museo Borbonico*.

16

This dish of meat is too good for any but anglers
or very honest men
ISAAK WALTON

2

FISHING TO LIVE
Prehistory to the Middle Ages

Two caves in France, at Pindal and Niaux, contain the very earliest examples
known of fish represented in art. They may be as much as 25,000 years old
and they reveal that when man began to paint, he painted not just the bison,
the boar and the buffalo of the plain and the steppes, but also the hidden creatures
of river and lake. What special or unique significance these representations had for
the hunter-gatherers who painted them we do not know, but the fish was clearly
important. Fish hooks carbon-dated to 24,000 BC have been found in Southern
Moravia (now Czechoslovakia); fish carved in stone from Siberia date to 3,000 BC and
Chinese hooks date to 4,000 BC. The Egyptians endowed the fish with a special sym-
bology. Like the cat and the ibis, the fish was for the Egyptians an important part
of life and death. Fish are mentioned in the *Book of the Dead* but though they are repre-
sented on several tomb walls the exact significance of their presence is disputed; they
were regarded as ritually impure but were also revered. There is no doubt, however,
that one of the very earliest examples of angling in art comes from Egypt. In the tomb
of Kenamum at Thebes there is a highly stylised portrait of an angler who appears
to have a multitude of lines attached to his rod. The picture dates from 1,400 BC and
it indicates that angling, as a relaxing pastime – the fisherman in the picture is sitting
down – was already established.

Representations of angling and fish in art increased dramatically with the rise of
Greek culture and civilisation. By the sixth century BC a number of Greek vases and
mosaics are found with striking and delicately drawn representations of anglers and

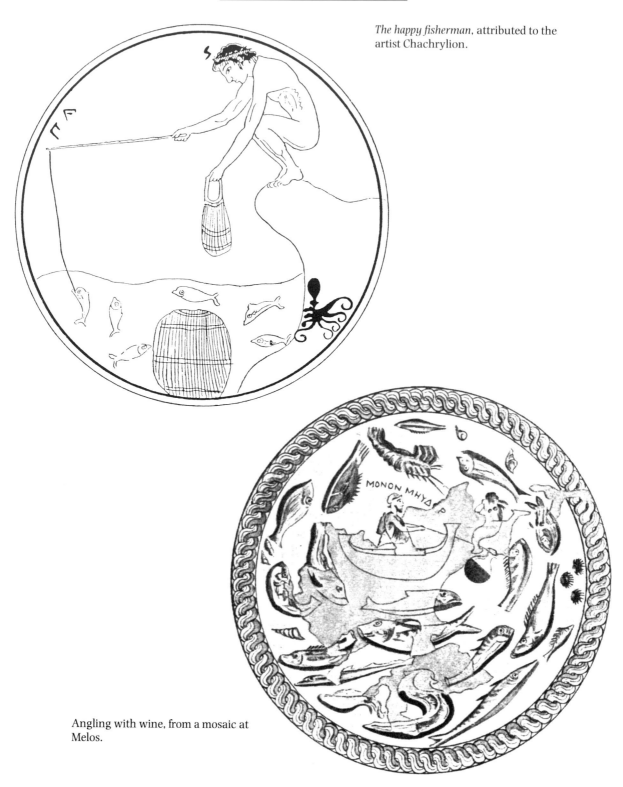

The happy fisherman, attributed to the artist Chachrylion.

Angling with wine, from a mosaic at Melos.

Greek literature is filled with images and metaphors of angling. Thus in Homer's *Oddessy* we find Ulysses saying: 'Even as a fisher on some headland lets down with a long rod his baits for a snare to the little fishes below . . . and as he catches each flings it writhing, so were they borne upward to the cliff [by Scylla].'

Already the image of the angler had become a powerful one. In Homer's *Iliad* we find the following: 'As when a man sits on a jutting rock and drags a sacred fish from the sea with a line and a glittering hook of bronze, so on the bright spear dragged he Thestor.'

In both Greek and, later on, Roman art and literature a tradition developed that the fisherman be portrayed as old and careworn. This is probably because angling was a means by which the very poorest eked out an uncomfortable existence. There are exceptions, however, including the happy fisherman attributed to Chachrylion. But already there were occasions when angling in art took on an idealised form in order to symbolise a carefree nature or even youth and dalliance. In a number of wall paintings at Pompeii, for example, idealised paintings of boys and women fishing are undoubtedly meant to represent not real anglers, but idealised figures.

Plutarch wrote that fishing is 'filthy, base, illiberal' (*De Sol Anima*), but in some ancient cultures – notably Hinduism – the fish is an important symbol of fecundity and it is therefore valued in art. And in spite of Plutarch's disgust anglers even appear on Roman coins. Moreover the Roman historian Macrobius reports that Crassus, 'first among the greatest Romans wept when one of his pet fish died'. It was apparently a mullet. Other ancient illustrations of angling appear on the mosaic from the Hall of the Mystae in Melos. This highly fanciful work shows an angler using wine as bait!

The ancient Chinese were using rods and reels more than 1,000 years ago that

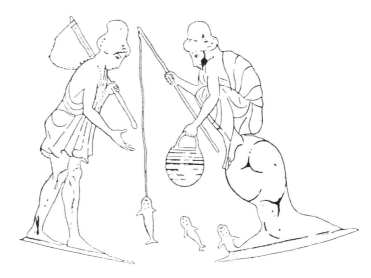

Fisherman and son, from a Greek vase.

19

Two men fishing, from coins of Carteia.

would be instantly recognisable to the modern angler, and they were certainly producing illustrations of the sport by this time.

Christianity is closely associated with fish and fishing. Fishing imagery even has a biblical context – Christ, for example, is often described as a fisher of souls. In Celtic Britain the fish appears often in art and it occurs most famously in the Romano-Christian ship burial at Sutton Hoo. Here Christian motifs are mixed with images from the Celtic and Roman worlds. Inside a ceremonial drinking bowl a fish is modelled in silver. If touched the fish spins on a pivot. Anyone looking into the bowl while it was full of liquid would see the three-dimensional model of a fish apparently swimming.

The Celts were masters of the art of wood carving, but almost nothing remains of their work in this medium. We do, however, get glimpses of their abilities through much worn, but still extraordinary stone carvings, some of which include representations of fish.

As we move out of the Dark Ages in Europe we find fish and angling pictures in illuminated manuscripts and in one or two of the world's earliest printed books. Probably the best known angling illustration from the late Middle Ages appears at the start of the oldest angling book published in English, *The Treatyse of Fishing with an Angle* (1496) written by Dame Juliana Berners and printed by Wynken de Worde.

The crude but effective woodcut that illustrates the Treatyse tells us a great deal about medieval dress and about the simple fishing tackle used at the time. Medieval misericords – wooden folding church pews – include numerous fine carvings of fish, most notably pike in the cathedral at Exeter. This great medieval church also contains a misericord carving in oak of a fish clasped by a mermaid, a symbol of the soul in the grip of earthly passion.

In England fish were associated with ill omens and terrible events. The origins of the belief are now lost but the deaths of Henry II and Cromwell were said to have been foreshadowed by fish fighting among themselves in the ponds and stews belonging to the two men.

At the close of the Middle Ages the fish had appeared often, the angler only rarely in art. But already the angler had come to have a symbolic significance; the portrayal of his sport could indicate a carefree life or a life of poverty. The object of his sport – the fish – had been used to symbolise the soul. But with the woodcut in Dame Juliana Berners' little book a tradition peculiar to England was begun, a tradition that led to the idea of angling not as an inefficient method for the old, the very young or the infirm to supplement a meagre existence, but as a means the greater to enjoy life. Angling in art was in its infancy, but it was soon to come of age.

A fishing scene, from the Manesse illuminated Manuscript.

The woodcut from *The Treatyse of Fishing with an Angle* by Dame Juliana Berners.

21

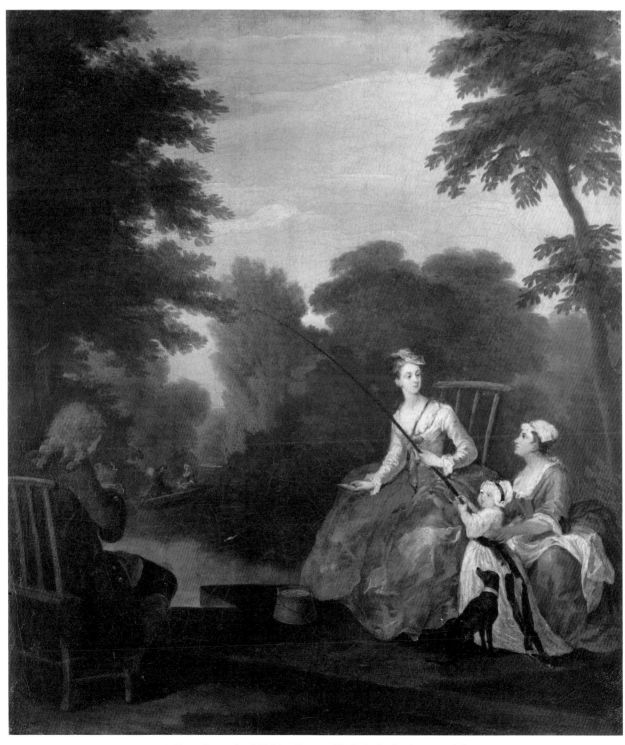

William Hogarth, *A Fishing Party – The Fair Angler* (*see page 26*).

Angling is somewhat like poetry: men are to be born so
ISAAK WALTON

3

FIGURES IN A LANDSCAPE
The Renaissance to the Age of Reason

As the Renaissance devotion to classical forms spread across Europe, man the noble creature aspiring to rise above his animal nature figures ever larger in art. Clearly angling was too small-scale, too mundane an activity still to have any real part in this burgeoning of interest in man the warrior, man the intellectual, merchant, nobleman, statesman. But in the pastoral landscapes painted by a number of Dutch, French and Italian painters the angler is occasionally given a role as an idealised detail in an ideal landscape. A good example is Nicolas Poussin's *Landscape with Orpheus and Eurydice* (1650), showing Orpheus with Eurydice at the moment, when she is about to be poisoned by a snake. The scene is one of gilded youth awaiting tragedy. But just behind the main figures is an angler whose role in the picture is clearly to suggest the peace and tranquillity that is about to end. His rustic presence, however insignificant a part it may play in the central meaning of the painting, nonetheless indicates the increasing importance of the angler as a symbol of tranquillity, a symbol of the individual removed from the cares of the world. As such the angler is a perfect, if unsophisticated focus of interest in many paintings.

In England, however, things were already developing in a slightly different way. The earliest known English portrait involving angling is a curious picture that has hung since it was painted in 1595 on the walls of the Common Room at Brasenose College, Oxford. At first glance the painting is entirely unremarkable. It shows Dr Alexander Nowell, principal of the college and Dean of St Pauls. The half-length portrait concentrates one's attention on Dr Nowell's hands, which are held loosely in front of him above a table. He looks out impassively from the canvas, but then we notice

Alexander Nowell, DD, 1595.

the curious fact that he is holding a packet of fish hooks. Some have slipped on to the table from the paper in which they were folded, but they are painted accurately and it is tempting to speculate that the unknown painter was asked especially by Dr Nowell to include these highly idiosyncratic items simply because the sitter wanted to indicate, however discreetly, that angling was his favourite pastime.

The solemnity of the portrait of Dr Nowell is entirely undermined by the discovery of the fish hooks. The idea that a man should have his portrait painted in such a way as to tell the world that he had a particular sporting interest was certainly novel in England at this time. But this portrait prefigures much that was central to the idea of sporting art in eighteenth century England, by which time a man would often wish to be painted with his rod, his gun or his horses.

The earliest native born sporting artist in England was probably Francis Barlow (?1628–1704). Born in Lincolnshire, his earliest known work dates from 1648. He probably studied under the engraver William Sheppard who is described as a 'Face Paynter living in Drury Lane'. Barlow, who was a member of the Painters and Stainers' Guild, worked in oils, pen and wash. He also designed ceilings and panels with birds and animals. His earliest etched illustrations were for Edward Benlowe's *Theophila*, but he also produced some magnificent work for an edition of *Aesop's Fables* (1666). These illustrations were mostly of human figures, but by the mid 1650s Barlow had

become famous, as the diarist John Evelyn recorded, as a painter of 'fowls, beasts and birds'. In 1658 William Sanderson wrote, in his *Graphice*, that Barlow was among the modern English masters 'first for fowl and fish'. Few other references were made at the time to the skill with which Barlow painted fish, but his biggest and most impressive work, commissioned for John Evelyn's friend Denzil Onslow at Pyrford, Surrey reveals a masterful feel for the shapes, textures and colours of British freshwater fish.

Barlow died in London in 1704. Such was his fame both during his lifetime and after that a number of artists, including the great Bohemian engraver, Wenceslaus Hollar (1607–1677), produced engravings of Barlow's work. Hollar's copperplate engraving *River Fishing*, after Barlow, was published in 1674. It is finely drawn and dramatic in composition, but absurdly overcrowded.

Hollar was born in Prague, then part of Bohemia, and although the details of his life are sketchy it seems that rather than follow his father into the law, he was sent to learn the art of engraving from Mathew Merian, a famous Bohemian engraver. Hollar later travelled to Germany and Antwerp where his work was noticed by Thomas

Wenceslaus Hollar's engraving, *River Fishing*, 1671, after Francis Barlow.

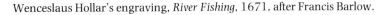

With flu and Codnet in your Swifter Streame, | **RIVER FISHING** | and many smaller Fish, they plunge with poles,
Pike, Pearch, and Chub they take, with store of Breame, | | great Shoeles to nett, from harbering in their holes.

Howard, Earl of Arundel, who invited the engraver to England. In 1640 he was appointed drawing master to the prince, later Charles II, but after fighting on the Royalist side during the Civil War he was captured and taken prisoner before escaping to Antwerp where he continued to work as an engraver. He returned to England in 1652 and died in 1677 at the age of seventy. He died in poverty, but was apparently much liked and admired. His work was wide-ranging and generally of high quality, covering portraits, biblical and historical subjects, maps, flowers, birds and fruit, but he is best known today for his views of Richmond and Greenwich.

Hollar died some twenty years before the birth of William Hogarth (1697–1764) who painted at least two great angling portraits, *A Fishing Party – The Fair Angler* and *The Pascall Family and Mr Pascall Angling*. By 1749 Hogarth was busily satirising the portrait painters in his *Apology for Painters*: 'Nine parts in ten of such a picture is the work of the drapery man and all the reputation is engrossed by the fismonger for what is contained in an oval of about five inches long.'

In spite of his later disgust for the profession, Hogarth had been employed as a face painter by Henry Wootton, but he had also made his living in the 1720s and early 30s as a painter of small groups and conversation pieces, of which *A Fishing Party – The Fair Angler* is a good example. Although painted in what has been described as Hogarth's most French manner, the picture is entirely convincing as an angling scene. The lady is clearly waiting for the man in shadow on the left of the picture to rebait or adjust her hook, while the child, eager to participate, tries to wrest the rod from its mother's grasp. Sadly the identity of the sitters is not known, but the picture is a delight. Hogarth went on to become famous for his moral pictures – *The Harlot's Progress*, *A Rake's Progress* and, in 1745, his masterpiece – *Marriage à la Mode*, but his earlier works, including his angling portraits, are an important part of his development.

Throughout the eighteenth century controversy raged among painters and their patrons about the value of portrait painting, for which demand was rapidly increasing. As we have seen, Hogarth attacked those artists who painted only their sitters' faces, employing others to paint in the less important parts of each portrait or group picture. But painters had always used assistants in this way if they could afford to do so and were sufficiently in demand.

Among the great eighteenth-century painters of small groups (conversation pieces) Johann Zoffany (1735–1810) had a real feeling for angling as part of a picture. His *A view in Hampton Garden with Mr and Mrs Garrick taking tea*, is a marvellous example. The Garricks are sitting on the left of the picture, but the central point of interest is Garrick's brother George who is fishing with rod and line. The picture sums up all that is most relaxing about the gentle art. David Garrick, the most famous actor of

Johann Zoffany, *James Sayer Aged 18 Years*.

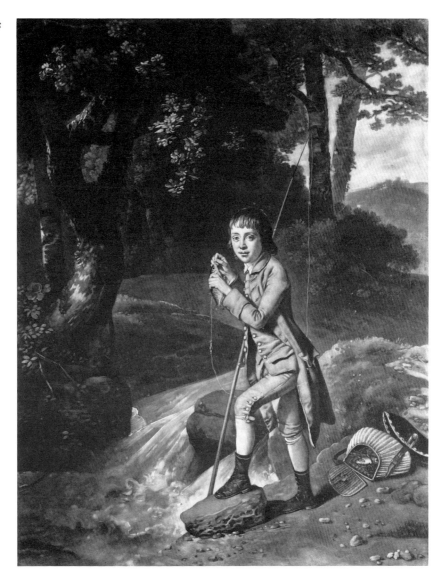

his age (1717–1779) was one of Zoffany's earliest patrons. Born in Frankfurt, Johann Zoffany studied in Italy before coming to England in about 1761. Early on he lived in some poverty, until he was rescued by a clock maker who allowed the artist to paint clock faces. From here he moved on to become a drapery painter for the artist Benjamin Wilson. A series of paintings of Garrick in different theatrical roles made Zoffany's name. The backgrounds in many of his portraits were painted by assistants, but his angling portraits are particularly good. His picture of *James Sayer Aged 18 Years* was reproduced as a fine mezzotint by Richard Houston in 1772. From an angling point of view it is a most interesting picture, with its detailed reproduction of rod and

creel. Unusually, too, for a picture of this period there is a genuine attempt to give the whole thing a realistic feel: the attitude of the boy as he unhooks the fish is exactly right. But it wasn't only children at this time who wanted to be painted enjoying their favourite pastime, as Zoffany's picture of *Mr & Mrs Burke of Carshalton* reveals. Here, rather than merely sit for their portraits the Burkes have deliberately indicated that they are sufficiently leisured to enjoy angling.

Throughout the eighteenth and early nineteenth century as the demand for portraits and conversation pieces grew – largely the result of the growth of a new middle class – numerous less well-known painters found they were being asked to include angling as well as dogs and horses in their client's pictures.

Arthur Devis (?1710–1787) was the leading exponent of the small-scale middle class conversation piece. He was a pupil of the animal painter Peter Tillemans who had

Arthur Devis, *Richard Moreton, his niece and nephew.*

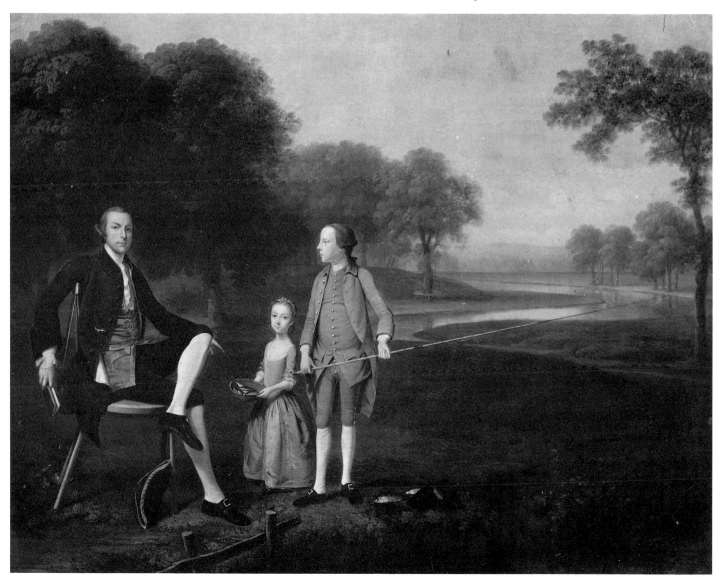

come to England from Antwerp in 1708. Tillemans was best known as a painter of animals and landscapes, but his pupil spent his life catering for the newly enriched. He specialised in painting whole length figures (usually these pictures would measure 24 × 16 in, 61 × 41 cm). Devis, who was born in Preston, was president of the Free Society of Artists and in his later years he experimented with painting on glass. At least two angling conversation pieces by him are known: *The Swaine Family*, and *Richard Moreton, his niece and nephew*. The latter work gives the impression that the two children have just come to their uncle from the river bank to show off their catch (held by the little girl). Richard Moreton has time to look up at the painter before his likeness is captured for ever.

The animal and sporting painter George Morland (1763–1804) who drew everything from pictures of ferreting to narrative paintings, landscapes and groups, was said to have painted a picture a day at one stage in his life. He was born in London and his first picture was exhibited at the Royal Academy when he was just ten. He was a child prodigy who was first taught by and then rebelled against his father. It was said that his love of gin was so great that clients would arrive at his studio with money in one hand and a bottle of gin in the other. He spent almost his entire life running from his creditors in spite of the fact that he was one of the most successful painters of the day. As fast as he painted and sold his pictures he spent the money they brought in. Eventually he became a bankrupt and was imprisoned in 1799. He was to die in prison where he wrote his own sorry (and curt) epitaph: 'Here lies a drunken dog.' In spite of his self-destructive life, Morland painted a large number of very fine pictures (and perhaps a greater number of indifferent if rapidly composed ones) and many were copied and faked even during his own lifetime. His delightful group, *A Party Angling*, mezzotinted by George Keating and William Ward, shows what looks like a perch being landed by one member of a riverboat party. The young lady on whom most of the light falls at the centre of the picture is clearly the focal point, but the action and activity (in what appears to be a dangerously crowded boat) give the picture a true sporting feel. (*See page 30.*)

In Scotland the great portrait painter Sir Henry Raeburn (1756–1823) painted anglers, either fishing or getting ready to fish. Unlike Hogarth, Raeburn never despised the portrait painter's art – indeed he said of it once 'it is the most delightful thing in the world'. He painted more than 600 pictures in his lifetime and could get through five sittings a day. He was first apprenticed to a goldsmith but painted miniatures when he could of his friends. He fell out with his goldsmith employer or was sent by him (the story varies) to study under the Scottish portrait painter David Martin. After visiting London and Italy he returned to Scotland and became the greatest Scottish portrait painter of the day. He was knighted in 1822 by George IV and appointed His Majesty's

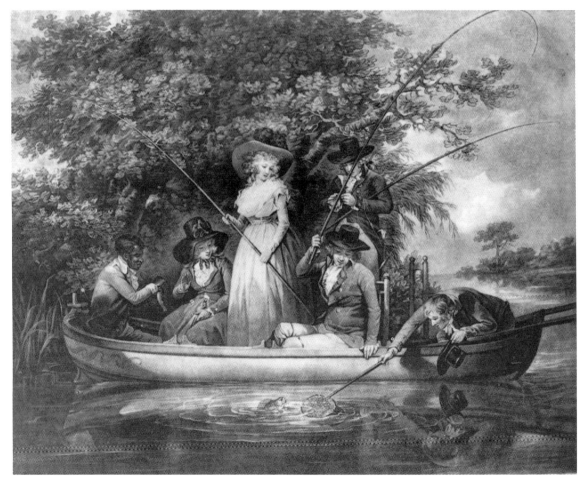

A mezzotint after George Morland, *A Party Angling*.

Limner for Scotland in 1823. Raeburn painted his subjects skating, or indulging in archery or, as in the case of *Lieut-Colonel Bryce McMurdo*, fishing. Though clearly the painter's intention was to convey the dignity of the sitter, this latter picture actually shows much of angling interest. McMurdo's rod is fitted, almost at the extreme end of the butt, with a winch and the rolled up cast being held in the sitter's hand suggests that he is tackling up at the start of the day. According to Raeburn's biographer Sir Walter Armstrong, the artist was a keen fisherman and this undoubtedly explains the attention to detail in the portrait.

Julius Caesar Ibbetson (1759–1817), apart from being splendidly named, was a splendid painter of cattle, pigs and portraits; most of his work is small, neat and perhaps

Sir Henry Raeburn,
*Lieut-Colonel Bryce
McMurdo.*

Francis Wheatley (?), *Three Children Fishing*.

a little laboured. Some of his drawings were engraved and published in 1793 as *Picturesque Views of Bath*. Ibbetson was born in Scarborough, was apprenticed to a ship painter, then painted scenery for the theatre at Hull and was certainly in London attempting to make his fortune by 1780. Ibbetson appears to have been a singularly unlucky man. His wife died in 1794; their eight children had all died by then and Ibbetson was so distressed by the whole thing that he collapsed into a fever and awoke to find that his servants had stolen everything in the house. Towards the end of the century he lived in Westmorland, travelled in Scotland and settled finally at Masham in Yorkshire.

Ibbetson's best known angling picture is of the painter *Ozias Humphry, R.A., Angling on the River Dart*. This is a curiously mannered picture – given that the angler is playing a fish he looks far too relaxed, but the painting does have great charm and the face of the angler at least shows some concern that the fish should reach the bank (*see Plate 1*).

Francis Wheatley (1747–1801) painted a number of pictures involving angling including *A Waterfall, on the Liffey*, now in the National Gallery of Ireland in Dublin.

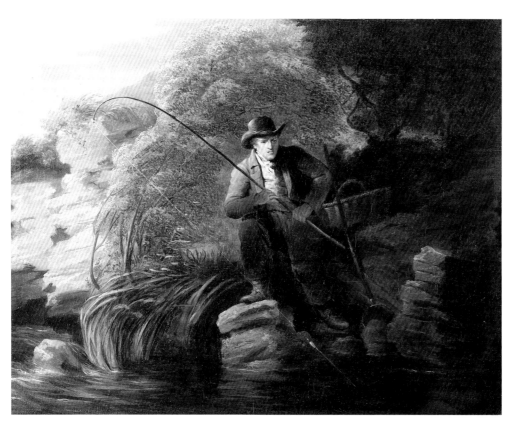

Julius Caesar Ibbetson (1759–1817), *Ozias Humphry, R.A., Angling on the River Dart.*

PLATE 1

(*below*) William Jones, *A River Landscape.*

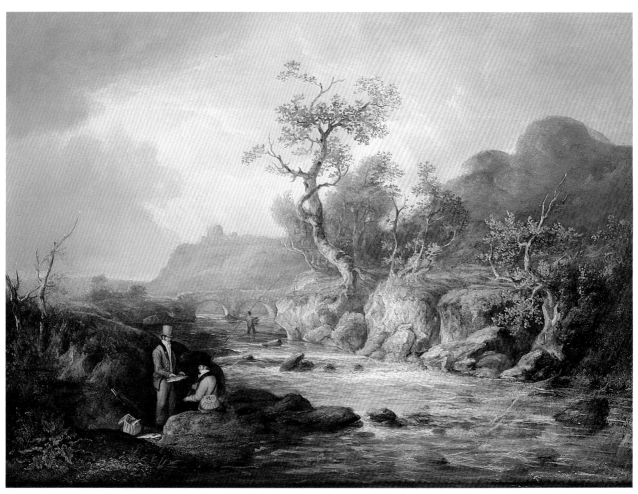

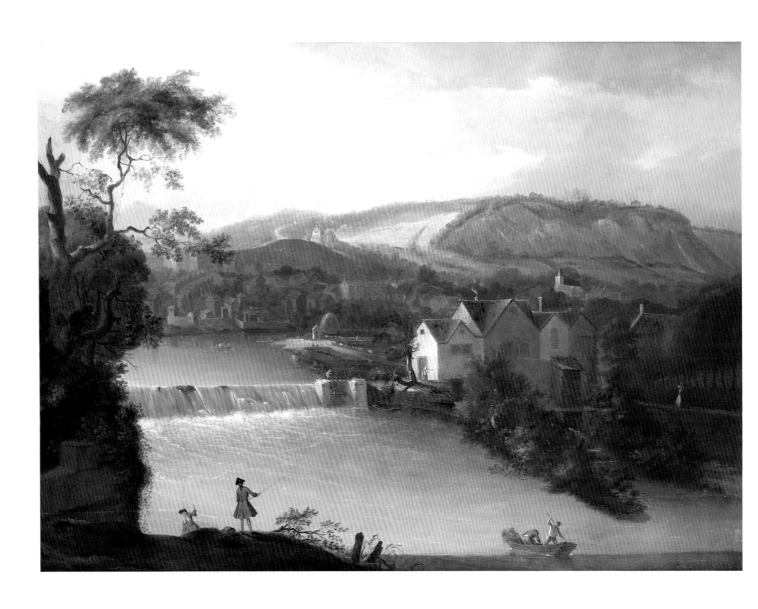

PLATE 2 Thomas Ross (fl 1730–1745), *The Weir and Bathwick Mill*.

An extravagant man, always in debt, he compounded his difficulties by eloping to Dublin with another artist's wife. He specialised in light, airy scenes of everyday or peasant life which lent themselves to the increasingly popular technique of stipple engraving. *Three Children Fishing*, though possibly by a follower of Wheatley's, perfectly illustrates his almost transparent style.

Philip Reinagle (1749–1833) was one of an extraordinary family of more than twelve artists. The first Reinagle arrived in England from Hungary in about 1745 as a supporter of the Young Pretender. Philip was born in Scotland and studied with Alan Ramsey (1713–1784) whom he assisted in numerous portraits of George III and Queen Charlotte. Reinagle abandoned portraits for animals in 1785, but not before he painted the small but fascinating portrait of *Mr Knapp fishing for trout*. The picture measures just 7 × 11 in (18 × 28 cm), and though sketchy and perhaps crude it reveals that already the angler was starting to get burdened down with numerous bags and nets! Though not the most talented of portraitists, Reinagle was a superb copyist and

Philip Reinagle, *Mr Knapp fishing for trout.*

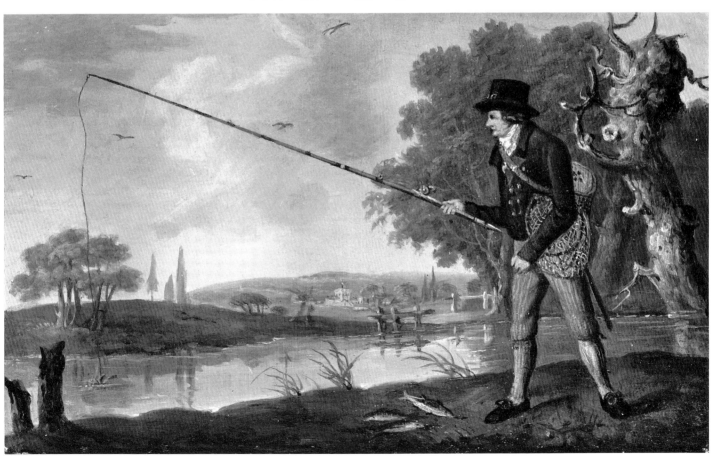

many of his copies of pictures by Dutch masters like Hobbema and van de Velde were (and probably still are) passed off as originals. Reinagle was also a supreme painter of spaniels and birds. In 1803 he illustrated Taplin's *Sportsman's Cabinet*.

Though, as we have seen, many eighteenth-century portrait painters included a few angling pictures in their work, the bulk of angling art of this period is contained in landscapes. Angling often provided the landscape painter with a focus, and a human one at that. Of course cattle, sheep and other animals might be alternative points of interest but how better to emphasise the tranquillity and peacefulness of a scene than by including a sporting figure renowned (with how much justice it is difficult to say) for his quiet and peaceable nature.

With many landscapes it is as if in letting the angler get down to the river we lose his identity and the emphasis shifts from an identifiable man or woman (as in a portrait or conversation piece) who is the real point of interest, to the landscape where the figure is distant and anonymous.

Some painters, like Edmund Bristow (1787–1876) painted his landscapes with the figures very much to the fore – as in his attractive *Two Boys fishing at Clewer Point on the Thames*. In a sense this painting is halfway between a portrait or conversation piece and a landscape. The identity of the boys has been lost or perhaps they were entirely figments of the artist's imagination. As well as landscapes, Bristow specialised in sporting and animal subjects. His *Wooded River Landscape at Dusk with a fisherman and his family* puts the angling interest at the centre of the canvas with the landscape, the boat on the river and the distant figure on the bridge all contributing to the sense of realism.

Bristow lived until 1876, but his style owes far more to George Morland and other eighteenth-century painters than to the Victorians. Bristow was a recluse who disliked patronage and he would often refuse to sell his pictures. He died forgotten, but his pictures are always workmanlike, occasionally excellent and much sought after today.

Though he also lived well into the Victorian era, J.M.W. Turner (1775–1851) is very much a product of the eighteenth century. He is also undoubtedly Britain's greatest watercolour landscape artist and it is among his watercolours that we find a large number of angling pictures. Turner's one consuming interest, outside earning his living as a painter, was angling. He was a member of the most exclusive angling society in the world – the Houghton Club, which still exists today. He is in fact the only really great British painter who was also a keen angler. However, he was never so foolish as to believe that a good angling picture had, of necessity, to involve technical accuracy. If he paints a view of a river and an angler is visible, the angler will be visible much as he would be if we happened to be in the position of the painter. In other words he may be partly obscured by mist or haze or by rocks and trees. Some

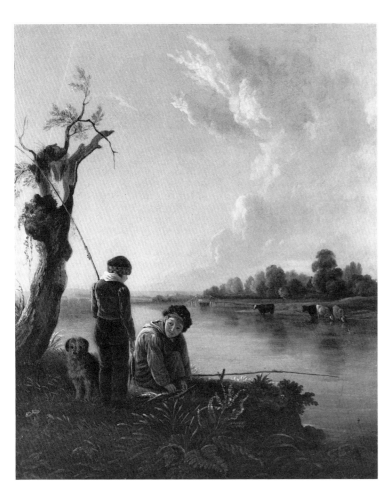

Edmund Bristow, *Two Boys fishing at Clewer Point on the Thames*.

(*below*) Edmund Bristow, *A Wooded River Landscape at Dusk with a fisherman and his family*.

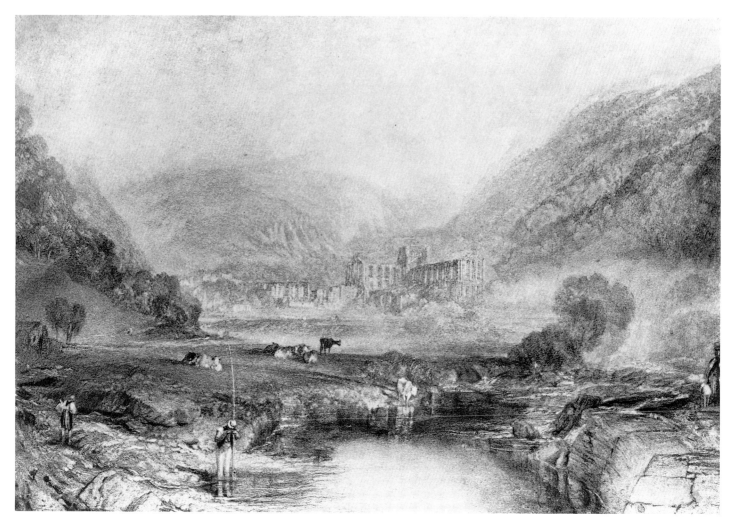

J.M.W. Turner, *Rievaulx Abbey.*

critics have argued that where the figure of an angler appears in a Turner watercolour it is often almost unnecessary to the effect of the picture. This may be true but it is hard to believe that Turner would have gone to the trouble of adding figures if he did not think the figures were an essential point, however small, of human interest. And he added anglers because he was interested in angling.

Certainly in a picture like *Rievaulx Abbey*, probably painted in the mid 1820s, the vast, distant edifice of the abbey contrasts with the figure of the angler in the foreground who is tying on a new fly. And the same is true of *Bolton Abbey*, painted about the same time. Here the figure of the angler with his rod and catch lying beside him, give the picture human scale and interest. The height of the trees and distant cliffs is emphasised through the contrast with the figure of the angler who has been painted sitting down.

The details of Turner's life are well known. His early years were spent colouring prints and washing in backgrounds for architects' drawings. Then, from 1793 he spent several years travelling the country, mostly on foot, painting and drawing as he went. Turner attributed his great success in life to one picture: *Norham Abbey on the Tweed.*

He was commissioned to illustrate a number of local histories and it was through this commission that he met his lifelong fishing and shooting companion Walter Fawkes. Turner stayed at Fawkes' home, Farnley Hall in Yorkshire, for several of his sketching tours and he completed a series of drawings of birds for his friend known now as the Farnley Hall Ornithological Collection.

Between 1808 and 1826 Turner lived at Hammersmith and then at Twickenham where he kept a boat on the Thames and fished regularly. In 1827 he published the first part of the biggest series of prints after his drawings for the collection entitled *England and Wales*. Turner oversaw the engraving of his pictures, working with William and George Cooke, two of the top engravers of the day. It is agreed generally that with the 100 plates completed between 1827–1838 he immeasurably improved the art of engraving. In 1832 he visited Venice and thereafter produced large numbers of pictures of that city. In 1835, among other work, he exhibited a painting called *Line Fishing off Hastings*. In 1838, publication of the series *England and Wales* was discontinued and Turner bought all the plates from which his drawings had been

J.M.W. Turner, *Bolton Abbey*.

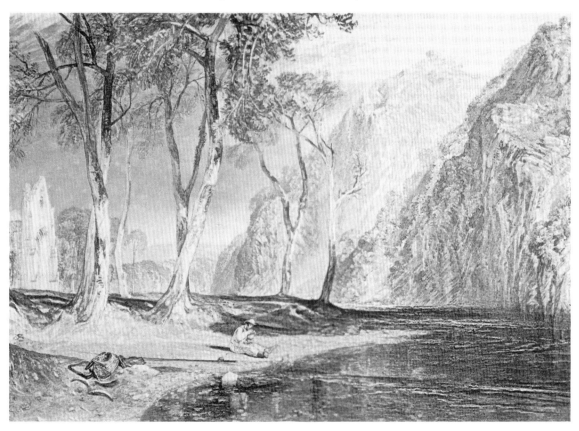

reproduced. Towards the end of his life he bought a second house in Chelsea and lived there, curiously, under the name Admiral Booth.

It is not fanciful to suppose that Turner first acquired his love of angling while he was at school at Brentford, a village on the Thames, and at that time some dozen miles west of London. Certainly he fished on and off throughout his life and even a brief list of his angling paintings is impressive: *High Force or Fall of the Tees* and *Egglestone Abbey near Barnard Castle* (both from the drawings for *The History of Richmondshire, 1816–23*); *Moor Park near Watford on the River Colne* (*Rivers of England, 1822–26*); *Lancaster from the Aqueduct Bridge, Rievaulx Abbey, Bolton Abbey, Barnard Castle, Walton Bridge, Eton College, Brinkburn Priory, Northumberland, Llangollen, North Wales* (all from *Picturesque Views in England and Wales, 1825–38*).

In a sense we could argue that Turner is Britain's greatest angling artist but that would be to suggest a narrowness of aims that he does not possess. All the watercolours listed above were drawn to be reproduced for a wide public that wanted beautiful pictures of interesting places, not interesting pastimes. Nevertheless it is true that Turner, more than any other major artist, found room for angling in his work.

The eighteenth century produced many other landscape painters of widely varying

George Barret, *A view on the North Esk with gentlemen fishing.*

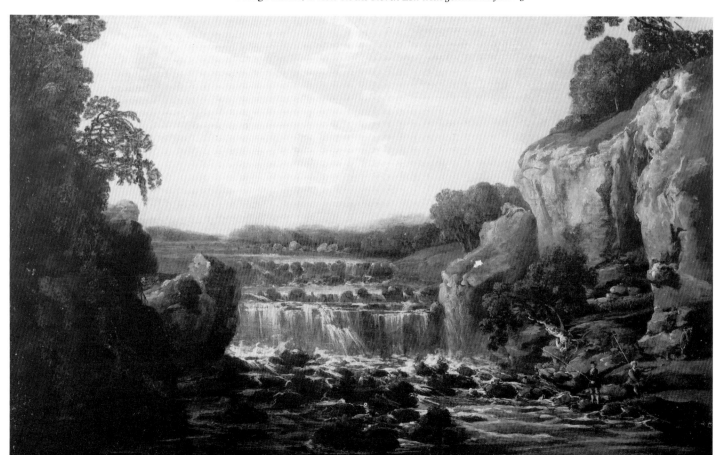

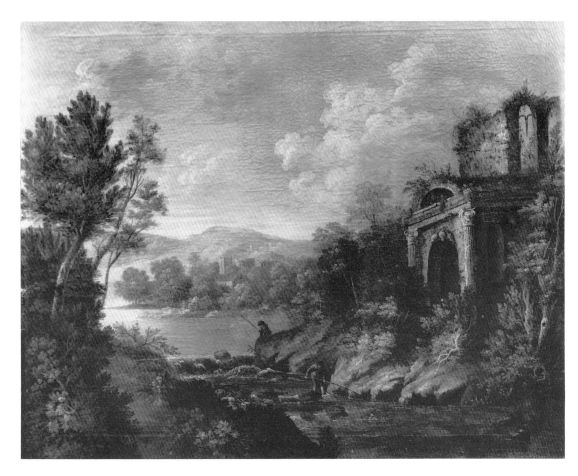

John Butts, *Wooded river landscape with fishermen.*

talents. Some are so obscure as to be known by only one or two pictures. Others, like William Jones, share their names with so many other obscure artists that it is now often difficult if not impossible to work out exactly who painted what.

A splendid picture by William Jones (at least three William Joneses are known to have been working as landscape painters toward the end of the eighteenth century) is a particularly good example of angling as more than an incident in a landscape. Two anglers in the foreground are admiring their catch while further up the river another angler is wading and fishing. The picture has a marvellous sense of light and space (*see Plate 1*).

Two Irish painters at work during the middle of the eighteenth century – and who certainly painted a number of angling pictures – were John Butts who died in 1764/5 and George Barret, who lived from 1728–1784. Barret is the better known of the two artists: he was a founder member of the Royal Academy and highly thought of during his lifetime if subsequently more or less forgotten. He was born in Dublin and started life as a staymaker before turning to art. He painted rapidly and skilfully, earned a great deal of money, and often employed the sporting painter Sawrey Gilpin to paint in horses. *A view on the North Esk with gentlemen fishing* is typical of Barret's work with its rather floppy trees and pale sky.

John Butts is now almost forgotten. Like Barret he was an Irish painter who turned his hand to landscapes. He also worked in Dublin as a copier and forger for a dealer.

39

George Arnald, *A wooded river landscape with peasants fishing.*

George Jones, *Gentleman pike fishing on the River Devon.*

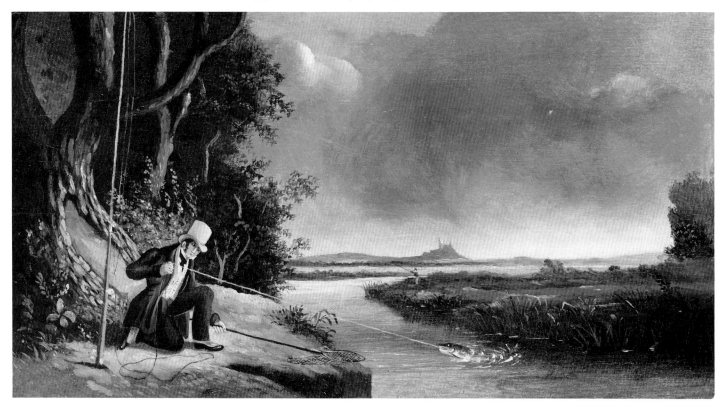

His *Wooded river landscape with fishermen* betrays what was for him a lifelong interest in vaguely classical landscapes.

George Arnald (1763–1841) painted large numbers of landscapes in the early part of his career, only to turn to marine painting later in life. His pictures, including two wooded river landscapes with anglers, have a certain charm, but little originality or power. Unfortunately, too, his pictures have a drab feel, although he was keen enough on angling to make it the focus of several of his pictures. One or two angling pictures in his style have also come down to us. A number of splendid angling landscapes were painted by George Jones (1786–1869) whose *Gentleman pike fishing on the River Devon*, if we accept it at face value, shows that in the final stages of battling with a fish our eighteenth- and early nineteenth-century ancestors resorted to handlining.

A master of the small landscape was J.A. O'Connor (1791–1841) another Irish painter who was apparently much liked as a man if not admired as an artist during his lifetime. His attractive, finely painted picture *Gentleman fishing below a lock*, which measures $7 \times 8\frac{3}{4}$ in (18×22.5 cm), is typical of his work.

The great watercolour painter David Cox (1783–1859) often included angling subjects in his paintings. Most of his pictures are either landscapes, coastal scenes or rustic genre works. He was born in Birmingham where he started work as a theatrical scene

J.A. O'Connor, *Gentleman fishing below a lock*.

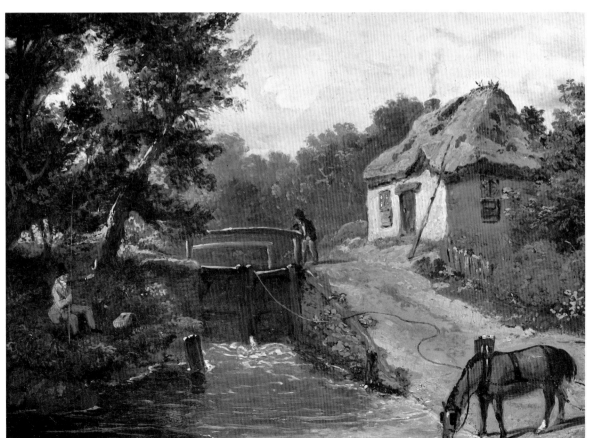

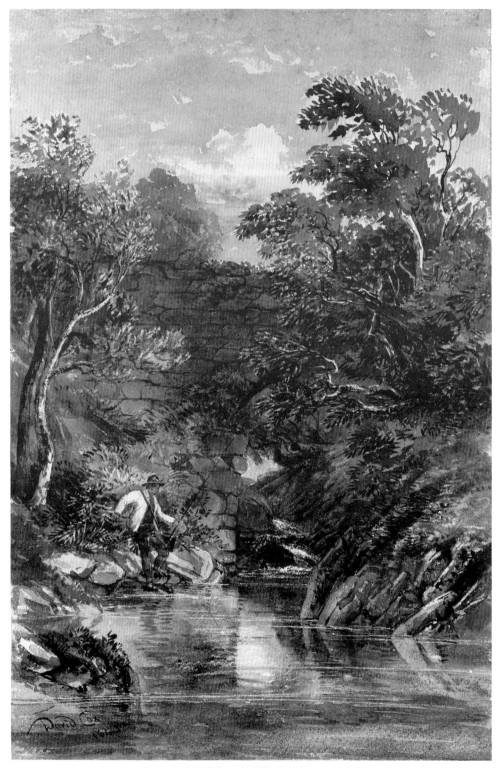

David Cox, *A Risky Position.*

painter. In 1804 he went to London to study painting under John Valey. He worked variously for the Military Academy at Farnham and at a school in Hereford. Cox used a special rough textured paper available only from a firm in Dundee (that used it solely as a wrapping paper), which was ideal for his rapid, bold brush strokes. One of Cox's best angling pictures is *A Risky Position*, which dramatically portrays a problem that has faced every angler at some time or another – getting into a slippery position in the hope of making an accurate cast to a fish. Painted in 1843 the picture has a light, almost impressionistic feel. The style contrasts markedly with Cox's *River scene with boys fishing*. Here there is a bleak, windswept feel with birds drifting across a wide East Anglian sky.

John James Chalon (1778–1854) was one of a large number of European artists who came to Britain during the eighteenth century. Chalon was born in Geneva of

David Cox, *River scene with boys fishing*.

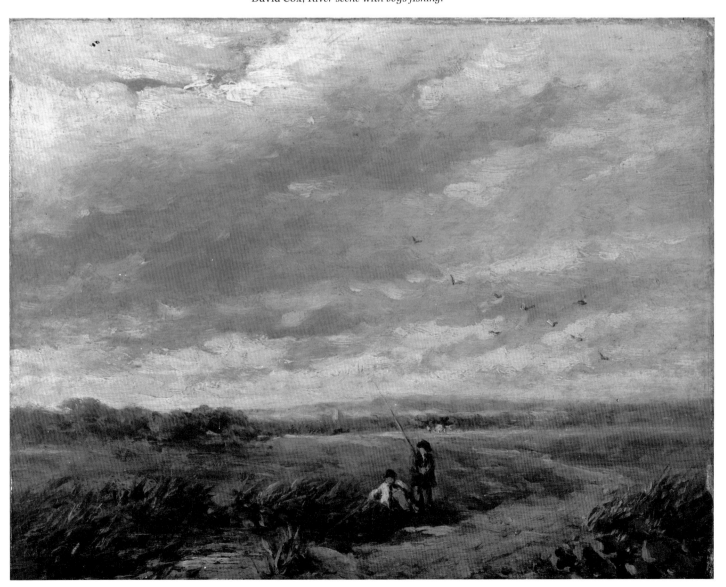

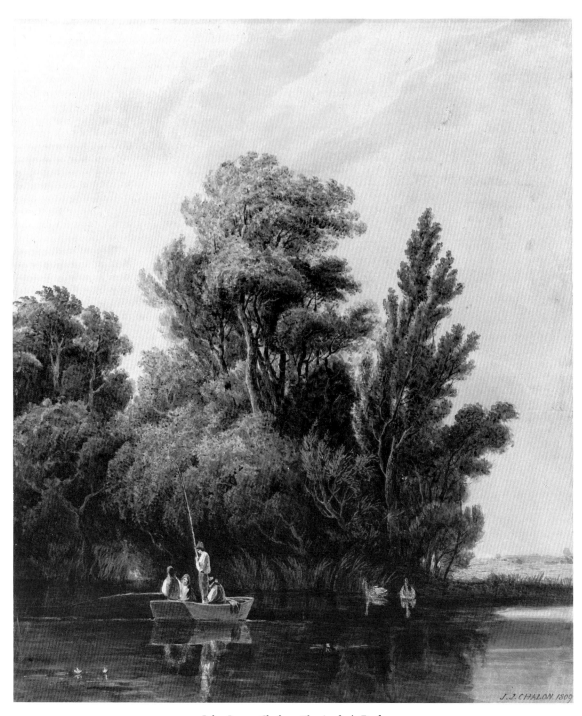

John James Chalon, *The Angler's Pool*.

French parents and came to England in 1789. Although he exhibited regularly for nearly fifty years he painted a relatively small number of pictures. However, he was a most accomplished artist who was occasionally drawn to angling as a subject, as his splendid picture, *The Angler's Pool*, shows.

Before we leave the eighteenth-century landscape painters, mention must be made of Thomas Ross who was active between 1730–1745. Like his near relative James (working 1729–1738), Thomas painted scenes around the Severn Estuary and Bath. Thomas and James belonged to a larger family of painters originally from the Gloucestershire/Worcestershire areas and their landscapes show the influence of the Dutch painter Peter Tillemans. Thomas painted a most interesting picture of *The Weir and Bathwick Mill* just outside Bath. In the foreground there are two anglers; one is holding aloft a fish he has presumably just caught. The panorama may be the main point of interest in the picture, but it is a good example of adding human interest and enthusiasm through angling (*see Plate 2*).

Alexander Cozens was a fascinating landscape painter who occasionally includes angling subjects in his pictures. He was said by his pupil, the writer and architect William Beckford, to be the bastard son of Czar Peter the Great, though this is now disputed. He studied in Italy and then taught at Eton. A highly skilled draughtsman

Alexander Cozens, *A Lake*.

who worked often in pen and ink, he occasionally launched into a broader, freer style for his landscapes. This is evident, for example, in his picture *A Lake*. Cozens' date of birth is not known but he probably died in 1786.

Henry Edridge (1769–1821) painted at least one splendid angling scene: *Two Gentlemen and their Catch*. This is the work of a miniature painter, a favourite of Sir Joshua Reynolds, who turned to landscape painting in 1789.

The Edinburgh painter Patrick Nasmyth (1787–1831) had to learn to paint with his left hand after damaging his right during a sketching expedition with his father. He liked to paint rural scenes with dwarf oaks and poor cottages and he was famous during his lifetime for his brilliant skies and low toned fields. His picture *The Angler's Nook* is clearly derived stylistically from the work of the Dutch masters, particularly Hobbema whom Nasmyth admired greatly.

John Crome (1768–1821) who helped found the Norwich School of artists with John Sell Cotman in 1803 painted a number of excellent angling pictures. He always painted in the open and earned his living partly by teaching. His colouring is always rich and he was a fine draughtsman who was particularly keen on painting trees, as his picture *Brathway Bridge* reveals. At the centre of this highly atmospheric painting are two boys fishing from the parapet of the bridge.

Henry Edridge, *Two Gentlemen and their Catch*.

Patrick Nasmyth, *The Angler's Nook*.

John Crome, *Brathay Bridge*.

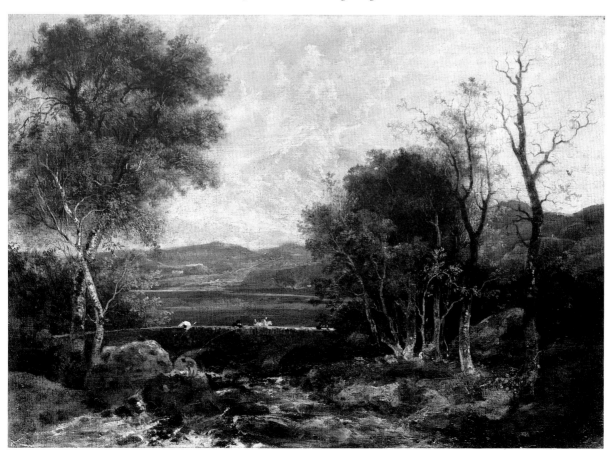

Henry Alken, *A Strike*, and (*below*) *Gaffing a Trout*.

PLATE 3 (*above*) Henry Alken (1785–1851), *On the Avon, Fordingbridge*. (*below*) James Pollard (1792–1867), *Trout Fishing on the River Lee, near Waltham Abbey*, 1847.

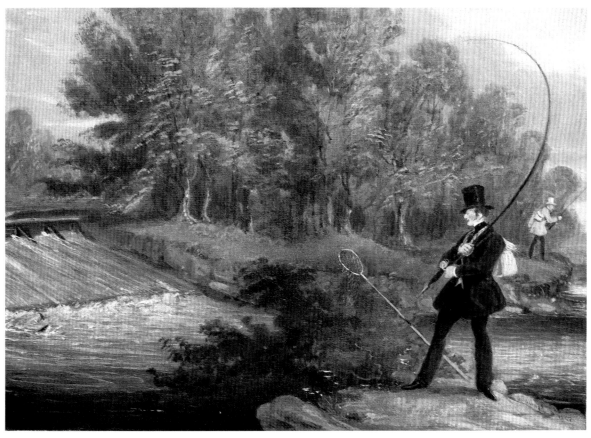

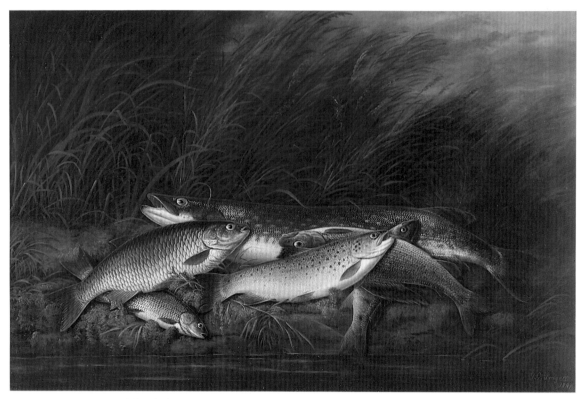

PLATE 4 (*above*) Thomas Targett, *Fish on a Riverbank*, 1877. (*below*) Frederick Richard Lee (1799–1879), *English River Fish*, 1834.

A worm at one end and a fool at the other
SAMUEL JOHNSON

4

THE GOLDEN YEARS
Eighteenth-Century Sporting Prints and the Victorians

So far as sporting painting is concerned most of us are familiar with the eighteenth century through prints of hunting and coaching scenes. The end of this century saw an explosion of interest in prints and printmaking as a wider public demanded cheaper, but equally attractive alternatives to original paintings. The great names of eighteenth- and nineteenth-century printmaking and design include the two Henry Alkens (father and son) and James Pollard and his father Robert.

Henry Alken (1785–1851) was the son of Samuel Alken, a landscape and sporting painter of Danish extraction. Henry was born in London and first studied with a miniature painter. He was a prolific painter in watercolours and oils of hunting, shooting, coaching and angling scenes, but he is best known through his prints, many of which were published by Fores. *A Strike* and *Gaffing a Trout* are typical of Alken's work which, so far as angling is concerned, concentrates not on the tranquil aspects of the sport but on moments of intense action, and though he was not always successful at imparting a realistic sense of action, his work is lively, engaging and dramatic. Henry's son was also called Henry and it has always been difficult to distinguish between the two men's work. They both signed their pictures H. Alken.

Though born in the eighteenth century, James Pollard takes us stylistically well into the nineteenth. He was born in 1792, but did not die until 1867. Like Alken, Pollard, whose father Robert also specialised in sporting paintings and engravings, discovered that there was a large market for pictures that put hunting, shooting and

49

James Pollard, *The Angling Party*.

fishing at the centre of active interest. Many of Pollard's angling pictures depict the river Lee in Essex and Hertfordshire, but they almost invariably show a fish being hooked or played or about to be netted or gaffed. An exception is Pollard's *Angling Party*, showing a crowded river scene of anglers who appear to be having lunch together, or perhaps packing up at the end of the day. This has a lighthearted feel, but it shows that Pollard was capable of moving away from routine pictures of anglers in action.

James Bateman (1815–1849) also painted hunting, shooting and fishing pictures

and although, like Pollard and Alken, he occasionally makes the angler look surprisingly clumsy – particularly when he is playing a fish – Bateman appreciated the need for action rather than tranquillity in his pictures.

Apart from the vast numbers of angling paintings and prints produced at the end of the eighteenth century and well into the nineteenth, the growth of interest in angling saw a dramatic increase in the numbers of humorous works or caricatures. Chief among the exponents of this art so far as angling is concerned was the amateur artist and caricaturist Henry Bunbury (1750–1811). Educated at Westminster and

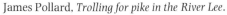

James Pollard, *Trolling for pike in the River Lee.*

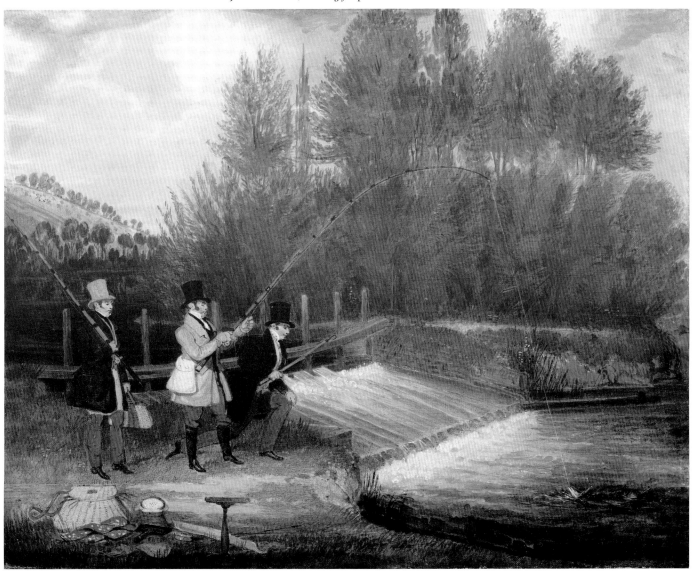

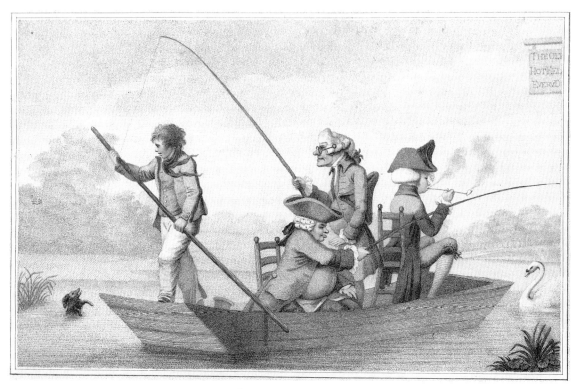

Henry Bunbury, *Patience in a Punt*, 1792.

Punt Fishing, possibly by Henry Bunbury.

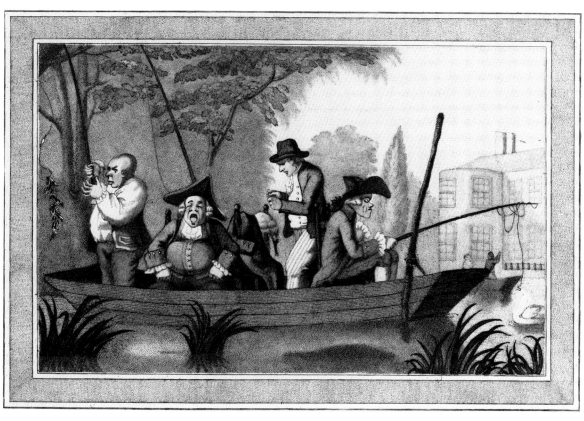

Cambridge, he studied art in France and Italy and although he produced a number of watercolour drawings and paintings he was best known and most admired as a caricaturist. He painted a portrait of Dr Johnson, illustrated the greatest comic novel of the eighteenth century, *Tristram Shandy* and provided a number of the best engravers of the day, including Thomas Rowlandson, with a large number of superb designs. His *Patience in a Punt*, a stipple engraving published by W. Dickenson in 1792 is a marvellous example of his humorous treatment of angling. The obviously overcrowded boat shows a short-sighted angler trying to land what might be a dog or a sheep, while a fat man also fishes and an apparent fop sits smoking a pipe. Crowds in angling pictures seemed to enable caricaturists to score easy points when they sought to suggest tangles, confusion or complete chaos.

An etching by and after a work by Robert Seymour (1800–1836) – he was known as Shortshanks and illustrated Dicken's first novel *The Pickwick Papers* – is a case in point. The picture shows a riotous uproar of anglers falling in, or getting entangled with each other, trying to land a pig and generally getting into the most appallingly confused state. From 1831 Seymour's output was prodigious. He illustrated a number of books, including *Maxims and Hints for An Angler*, and magazines. Always unstable, he shot himself just before Pickwick was first published.

Robert Seymour (Shortshanks), *Waltonizing or – Green-land Fishermen*, c 1820.

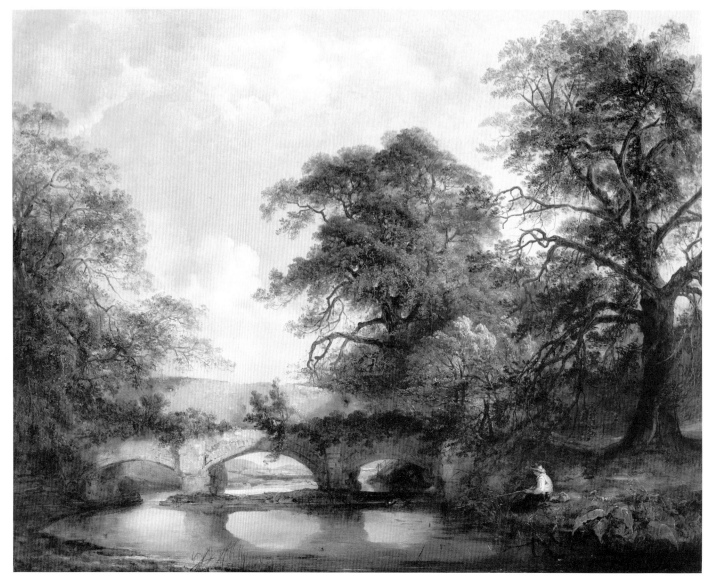

Frederick Richard Lee, *Wooded landscape with a boy fishing beside a bridge.*

As we have seen, the birth of angling in art in Britain took place in the eighteenth century, although no similar thread developed in other European countries. At the start of the century only one or two artists had produced occasional pictures of fish or fishing, but by the beginning of the nineteenth century the printmakers (and their artists) were cashing in on the vastly increased demand for sporting pictures that encompassed angling among the other sports. The portrait painters had established a tradition that included angling as an indicator of lifestyle and the landscape painters had moved on from seeing the angler simply as an ideal figure in a sylvan scene. They were now realising that angling could be portrayed as the centre of increasingly dramatic pictures.

Many of the eighteenth-century landscape and portrait painters I have discussed continued their work well into the nineteenth century, but the age of Queen Victoria

and the increasing growth of interest in angling as a sport for a wider range of people created a new momentum. Angling landscapes continued to be painted, but there was also a massive growth in the demand for still life paintings of the day's catch. And as we shall see, the nineteenth century produced a number of painters who actually specialised exclusively in this area.

Frederick Richard Lee (1799–1879) is one of the few artists who is recorded as accepting a specific commission to paint an angler's fish. In the 1860s a Mr Readleaf asked Lee to paint him a picture of 'dead game, fish, and still life'. Lee, an accomplished painter of Devon land and riverscapes, was no doubt happy to oblige. He is a curious figure who began his working life in the army. He served in Holland but had to give up a promising military career because of ill health, so he immediately decided he would be a painter and by 1818 he was studying at the Royal Academy. Although he concentrated on Devon scenery he also painted French and Scottish landscapes as well as a number of fish still life pictures. It is said that Landseer occasionally painted in Lee's animals, but Lee's *Wooded landscape with a boy fishing beside a bridge* reveals a talented if rather conservative painter. More striking is Lee's bright, bold picture *English River Fish*. This beautiful work shows superbly modelled pike, perch, trout, eels, chub, dace and gudgeon (*see Plate 4*). In the foreground is an angler's float and

the background of the picture includes a creel. Though apparently just a pile of fish, the picture is well composed and full of delightful contrasts of colour, tone and texture. Compare, for example, the scales on the carp with those on the trout; the very different textures of these two species are keenly observed. A small hook still rests in the mouth of a perch that has pre-sumably just been added to the bag. *English River Fish* was painted in 1834, just three years before the accession of Queen Victoria to the throne.

Stephen Elmer (1714–1796) another early exponent of the still life fish picture was a maltster who painted in his spare time. He was considered the finest painter of still lifes during his lifetime and his *Fish on a Riverbank* though unremarkable,

Stephen Elmer, *Fish on a Riverbank*.

Stephen Elmer (?), *Brown Trout and a pike on the bank.*

certainly reveals a competent draughtsman. The picture has a landscape background of some detail with windswept trees. *Brown trout and a pike on the bank* (attributed to Elmer) has a hurried feel to it but the trout are well drawn and the picture is typical of his work. The tradition Elmer helped start lasted until the end of the nineteenth century and the invention and popularisation of the camera.

Descended from a German engraver who probably arrived in England in about 1690, G.W. Sartorius was a member of a family of sporting artists and engravers working during the late eighteenth and early nineteenth centuries. The family included a Francis, two Johns, a Jacob and at least two others. The problem with distinguishing the work of different members of the family is that several signed the name Sartorius, but with no initials.

G.W.'s pair of still lifes, *Sea Fish in a Landscape* and *Freshwater Fish in a Landscape*, are attractive, colourful studies which go to some lengths to produce a realistic impression of each fish. Curiously the freshwater fish picture includes what looks very much

G.W. Sartorius, *Freshwater Fish in a Landscape*, and (*below*) *Sea Fish in a Landscape*.

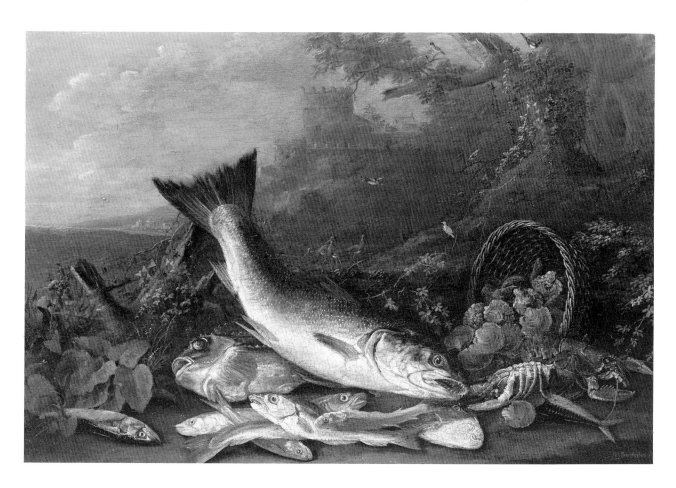

like a flounder. This might seem a mistake, but Sartorius clearly knew what he was doing – flounders are often found miles upriver from the sea and in water where the angler may frequently catch species as diverse as perch, trout, dace and chub.

Large numbers of still life paintings of fish were produced and left unsigned during the early nineteenth century. Many of the painters of these pictures were undoubtedly amateurs of varying degrees of ability, but time has given their work a charm and attractiveness that skill originally failed to impart. The list of such painters is almost endless, but among the names that occasionally crop up in auction catalogues are William Barraud (1810–1850), George Roth (at work 1810–1815), Thomas Ovendon (at work between 1817 and 1832), William Geddes (at work about 1850), John Russell (flourished 1870) and Thomas Targett (*see Plate 4*). Curiously as we move toward the middle and end of the nineteenth century, a number of women fish painters appear, among them Miss Agnes Eliza Haines (at work about 1887), Miss F.L. Hughes and Mrs Thomas Hume. Almost nothing is known of these artists but their paintings turn up from time to time and they bear witness to the spectacular growth of interest in preserving a good day's catch on canvas.

The great printmaker Fores was still at work towards the end of the nineteenth century and by this time he, too, was catering for the changing taste in angling pictures. One series of lithographs from Fores, published in 1889, show the trout's rise to the fly, its initial leap on being hooked, its weakening struggles and, finally, its capture and display on the bank. The series is a delightful example of action in

John Russell, *Still life of salmon and trout on a rock.*

A series of lithographs from Fores: *The Rise, The Leap, The Struggle* and *Landed*.

painting taken almost to the level of a series of stills from a film. Action, increasingly, is the byword.

Undoubtedly the greatest exponent of the art of fish in action independent of the angler (who we rarely see, but must assume to be attached to the other end of a line that disappears off the canvas) is A. Rowland Knight who was working at the end of the nineteenth century. Very little is known about his life. He was prolific and talented in a limited way, painting almost exclusively in oils. Although his fish – always shown in their natural habitat – are usually painted accurately and well, they are

59

A. Rowland Knight, six fishing pictures, each measuring $5\frac{1}{2} \times 8\frac{1}{2}$ in.

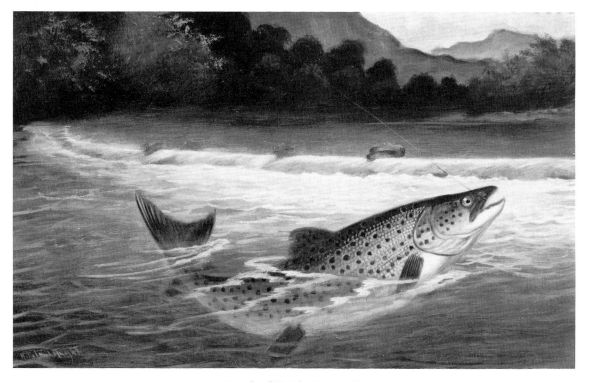

A. Rowland Knight, *Brown Trout.*

often found to be doing unlikely things. His lively (but absurd) picture *Lost by a Head* shows two almost identically sized pike rising simultaneously side by side from the water. One has caught a fish, the other not. The picture's charm lies in the fact that it is neither realistic nor naturalistic: it is in many ways almost naive (*see Plate 6*). Many other Rowland Knight paintings depict their fish subjects in a similar way but Knight is one of the most important and sought after of all angling painters. His work is distinctive, amusing, well coloured and drawn and original in conception. He realised that if there was a market for pictures of anglers playing fish, there would certainly be a market for a picture that zoomed in on the fish as it was drawn over the net or as it leapt at the end of the angler's line.

J.F. Lewis (1805–1876) was best known for his pictures of Italian, Spanish and oriental subjects. From his earliest years he painted animals, however, and he was much praised by Ruskin in the latter's influential book *Modern Painters*. In his early days before his first trip abroad in 1833, Lewis painted a number of most attractive pictures of peasants in Scotland. It is no surprise then that he occasionally painted angling scenes. A particularly good example shows an elderly – and singularly eccentric-looking – angler looking up briefly from the arduous task of flicking through his fly

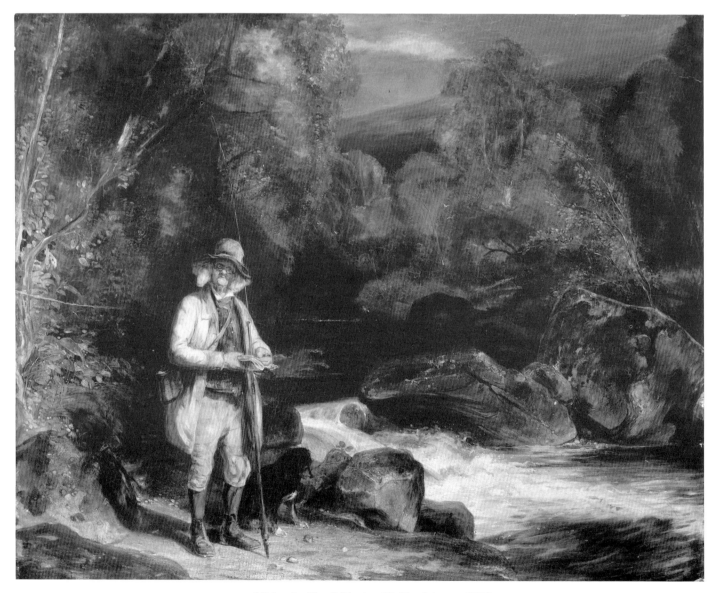

J.F. Lewis, *Man fishing in a Highland stream*, 1829.

wallet. The angler looks genuinely surprised as he stares out of the canvas toward the painter. He also has a distinctly raffish air and is certainly no idealised figure in a sylvan scene – something which typifies much eighteenth-century landscape painting that includes angling. Instead Lewis's angler has a distinct air of being serious and decidedly ordinary.

This sense of the ordinariness of anglers in art increases as we move through the middle and late nineteenth century and it is undoubtedly connected with the invention

of photography which gave people a taste for scenes that were at least apparently realistic, but also because English landscape painters had moved away from their heavy reliance on the style of the Dutch masters. The nature poets Wordsworth, Southey and Coleridge had, at the end of the eighteenth century and well into the nineteenth, encouraged a dramatic upsurge of interest in the wilder parts of Britain. Victorian landscape painters knew and understood this. And the fashion for wild places was further enhanced by Queen Victoria's keen interest in the Highlands of Scotland and the sports and pastimes of the area.

The paintings of Henry Dawson (1811–1878) illustrate the point. His landscapes have little of the fluffy, pastoral feel of much eighteenth-century landscape painting.

J.W. McLea, *Angling Scene*, 1841.

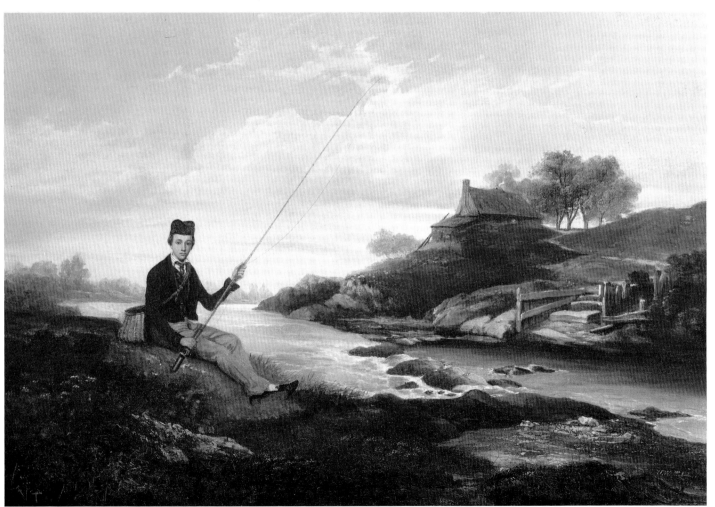

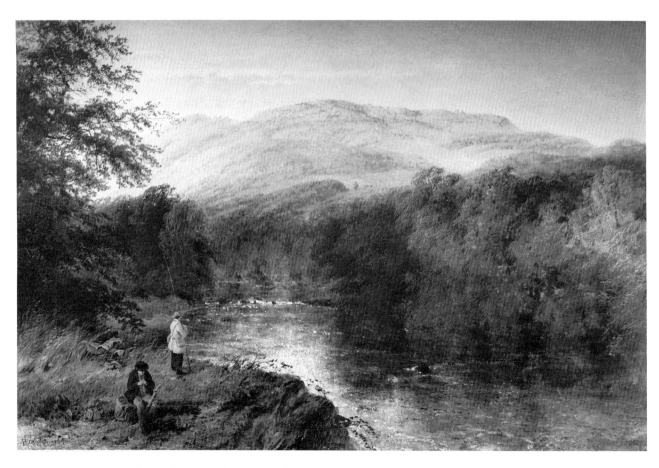

Henry Dawson, *Changing the Fly*, 1850, and (*below*) *Fishing on the Thames*, 1862.

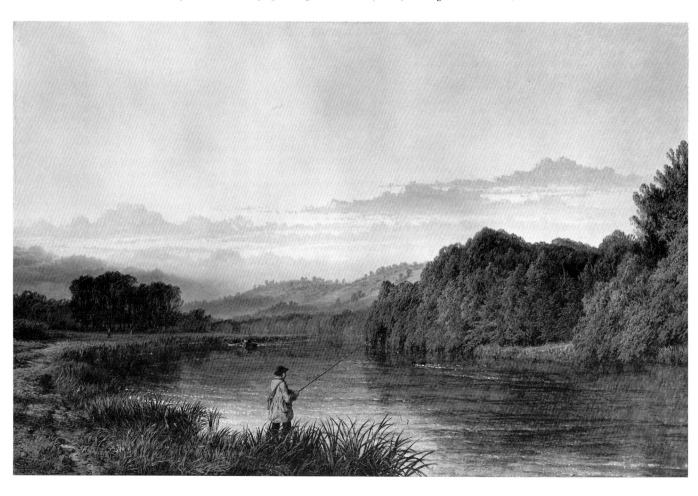

Instead his pictures look at least vaguely naturalistic with their bleak hills and wide, flat rivers. Dawson started life as a lace worker in Nottingham where he spent his early years. He was entirely self taught, which may explain why he painted what he saw without obvious reference to the traditions and styles of the past. His use of colour was much admired by the critic John Ruskin.

The Scottish landscape painter James Giles (1801–1870) is another good example of this trend. Giles was a keen angler who had toured Scotland extensively in search of subjects for his brush. His splendid picture of anglers by the side of a rocky river was painted in 1863 and it reveals the long rods then in use. It also shows what appears to be a gillie unhooking an angler's fish. The landscape behind the anglers has a genuinely wild, almost forbidding feel to it.

One of the best known, certainly one of the most amusing angling pictures of the nineteenth century is undoubtedly Theodore Lane's *The Enthusiast*. The picture, now in the Tate Gallery, was first exhibited in 1828 and although it gently pokes fun at the angling fanatic it is undoubtedly a good indication that by the early 1800s angling was already being seen as an obsessive sport, or perhaps more accurately a sport pursued by obsessives. Most fishermen will know exactly how the enthusiast felt as, forced

James Giles, *Anglers beside a river*, 1863.

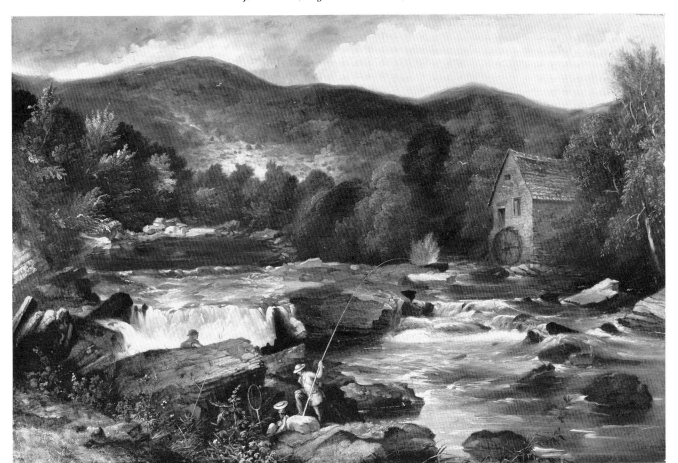

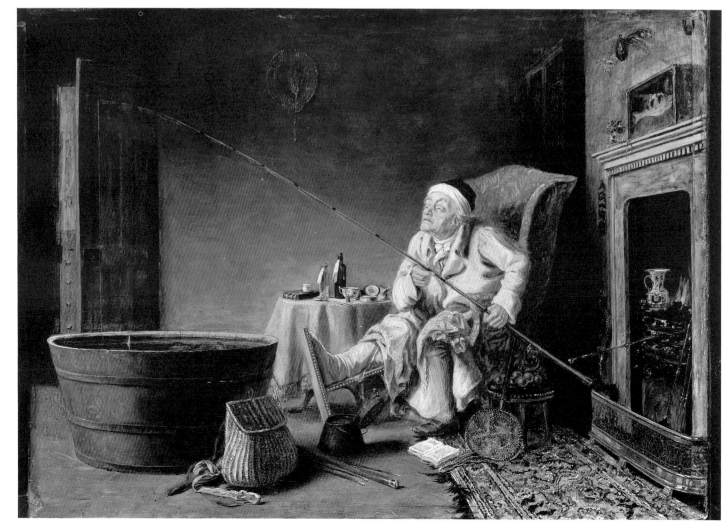

Theodore Lane, *The Enthusiast*.

to stay at home with an injured (or gouty) foot he sets up his tackle and fishes in a tub of water in his sitting room. Lane, who was born in London in 1800 and studied as a print colourer, died tragically early. He fell through a skylight in the Grays Inn Road in London and was killed instantly. He was just twenty-eight. His etchings and woodcuts had been used to illustrate *A Complete Panorama of the Sporting World* in 1827 and he was set fair for a brilliant career as a painter and etcher of sporting scenes.

Angling as an occasionally humorous subject clearly has its origins in the political cartoons and caricatures of the eighteenth century, but though the humour is still there, Lane's highly individualised angler has a far more realistic aura than the fatmen and fops of these antecedents.

The sentimentality of the Victorian era, though perhaps exaggerated by some critics, undoubtedly showed itself increasingly in the depiction of children in painting. And the child's association with the innocent pleasure of angling was a frequent subject for a number of painters.

John Constable (1776–1837) painted one superb angling picture: his *Young Waltonians* is a sensitive, highly accurate portrayal of the child's delight in fishing. The slightly older boys watch their lines patiently, while the two younger children lean over the bankside pilings to stare excitedly down into the water. In the distance are the trees and fields of that most familiar of all English landscapes, the woods and fields of Dedham Vale. Like the Impressionists, Constable was deeply concerned with the effects of light on his landscapes, but he loved the earthiness of his work too, the rush of water through a hatch, rotting bankside planks, piles and timbers and barges moving laboriously in the shining distance.

But the *Young Waltonians* was only the start of an increasing identification in the painting of children with the innocence of angling. As we have seen, Edmund Bristow painted two boys fishing the Thames, and David Cox had painted children fishing, but the fashion for this kind of picture and for pictures of children generally certainly increased as the century progressed.

William Bromley (1835–1888) painted a classic of this type. His *Three Children fishing*

John Constable, *Young Waltonians*.

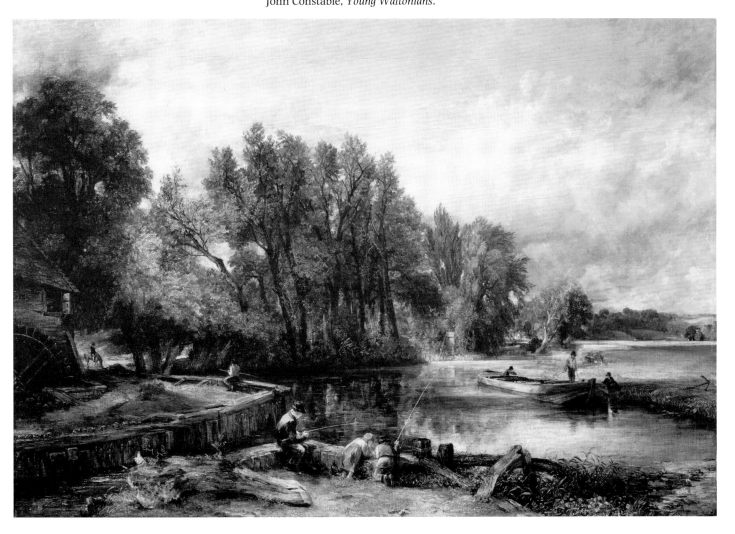

from a River Bank emphasises the innocence of the children with their delicately tousled clothes, their dreamy expressions and their decidedly homespun fishing tackle. The picture is colourful, well drawn and composed but it reflects a distinct idealisation of rustic children and is evidence of the tendency, through idealised painting, to escape the harsh realities of rural poverty and industrial squalor. In many way's Bromley's picture represents a sort of pictorial nostalgia for a never-never land of rural innocence (*see Plate 8*).

William Collins (1788–1847), painted a number of similar, idyllic scenes of children angling. Collins, who was born in London and studied at the Lambeth School of Art and in Paris, probably painted his *Young Anglers* at about the turn of the century.

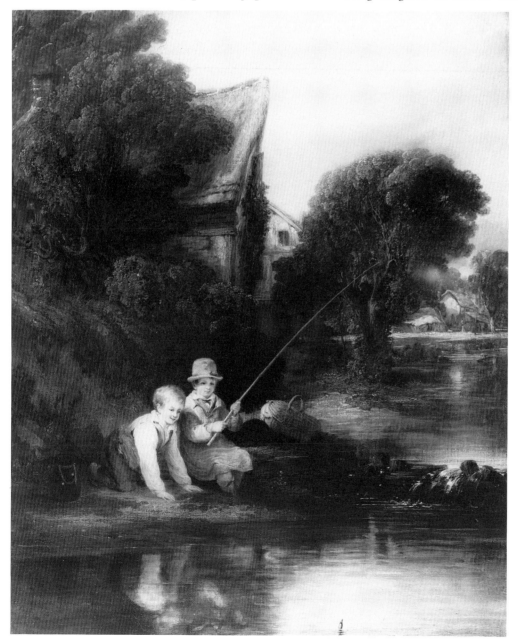

William Collins, *Young Anglers*.

William Collins, *The Prawn Catchers*.

It shows that, like many Victorian painters, he was increasingly drawn to some imagined ideal English landscape. That landscape, owing much to the lessons English eighteenth-century landscape painters had learned from the Dutch masters, is clearly seen in *Young Anglers*, but it is nonetheless a delightful if perhaps over-sweet picture. Collins' *The Prawn Catchers*, though not strictly an angling picture, shows that he was able to achieve a similar sense of childish wonderment in a beach scene.

H. Barstowe, a shadowy figure who exhibited between 1865 and 1869, painted at least one gloriously absurd picture of children fishing. His *Rustic Fisher Boys*, painted in 1869, has the typical Victorian depiction of children as hearty little innocents, but Barstowe has also managed to make his children look both ridiculously romantic (note the boy staring up at the girl on the bank) and startlingly earnest. This is particularly true of the boy waiting with arms outstretched. (*See page 70.*)

As the nineteenth century progressed the fashion for all things Scottish continued and grew. In the previous century the literary and artistic world had viewed Scotland, Wales and the Lake District as savage places to be avoided by civilised people. Boswell's *Journal of a Tour to the Hebrides* (1786) records, for example, Dr Johnson's indifference

H. Barstowe, *Rustic Fisher Boys*.

to the drama of Highland scenery. Johnson noted only that Scotland had almost no trees and that having toured the country he could quite understand why so many of Boswell's countrymen chose to live in England.

The nature poets, toward the end of the nineteenth century, turned this whole attitude on its head. Wordsworth emphasised for the first time in literature the brooding, emotional immensity of the stark lakes and fells of Cumberland and Westmorland and it was natural that a taste for the drama of the Lake District should eventually also encompass the drama and immensity of the Scottish Highlands.

Queen Victoria, the first modern monarch to visit Scotland regularly, made the Highlands fashionable and soon typically Scottish sports – stalking, grouse shooting and salmon fishing – became the pursuits of the fashionable and wealthy. And this has remained true to this day. Where the fashionable went, the painters and artists were

soon to follow. Landseer, the Queen's favourite painter, produced many dramatic sporting pictures of the Highlands – his *Monarch of the Glen* must be one of the best known (and most overrated) paintings in the world. But Landseer, unlike his near contemporary Richard Ansdell (1815–1885), was no angler. Ansdell owed a great debt to Landseer and indeed for some time early on in his career he copied Landseer closely both in terms of style and technique. In the end however, Ansdell went on to rival and then overtake his friend in terms of his ability to paint a wide variety of subjects in a range of styles. Ansdell worked for the Earl of Sefton and the Marquess of Bute, but he never gained the favour of Queen Victoria. The reason was probably that when asked to paint her dogs he refused to go to the Queen and asked instead that the dogs be brought to him. Following the vogue for Scottish subjects, Ansdell painted stags in glens, shooting scenes and an occasional angling piece. His *Gaffing the Salmon* has a remarkable, almost violent energy, but the picture, although perhaps attempting on the face of it to be realistic is, like much Victorian art, essentially melodramatic. The kilted gillie has wrenched the fish from the water with such force that we might almost think him in an extremely bad mood with his angler. The poor fish, being the only attackable and animate thing in the vicinity gets the full brunt of the gillie's wrath. Violent drama was something at which Ansdell excelled – he painted a number of battle scenes, for example. Much of his Scottish painting was widely known, like Landseer's, through the engravings of H.T. Ryall, but some of Ansdell's best works,

Richard Ansdell, *Gaffing the Salmon.*

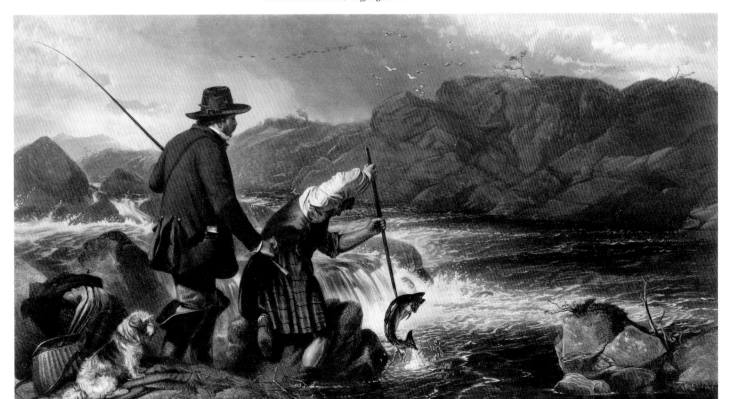

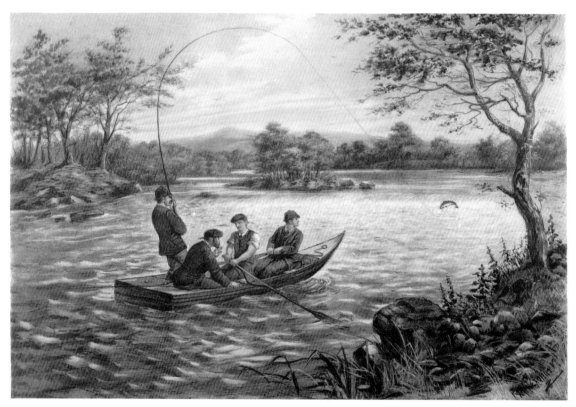

R.M. Alexander, *A Strong Stream and a Lively Fish.*

because they were never engraved, are much less well known. His large portrait groups, like the *Caledonian Coursing Club*, are among his more impressive paintings.

Toward the end of the nineteenth century before photography was firmly established, a number of reproduction techniques were invented or modified to mass produce the most popular paintings of the day. Angling subjects, still usually painted in the Highlands, are prominent among these.

Although a Londoner by birth, Douglas Adams painted Scottish loch and coastal scenes almost exclusively. He exhibited a number of angling pictures between 1880 and 1904, but very little else is known about him. His *Sea Trout Fishing* and *Salmon Fishing*, both part of a series of photogravures published in about 1898, show how much darker and more threatening the Highland landscape has become in art and it is tempting to believe that the Victorian tendency to the morbid and the gloomy is reflected here. Photogravure was a popular way of reproducing paintings during this period. It combined engraving and photographic techniques to produce a textured effect like paint on canvas.

Photolithography, another process for mass producing prints, was used to publish two pictures by R.M. Alexander, a Scottish painter about whom almost nothing is known. His *With the May Fly* and *A Strong Stream and a Lively Fish* are colourful and

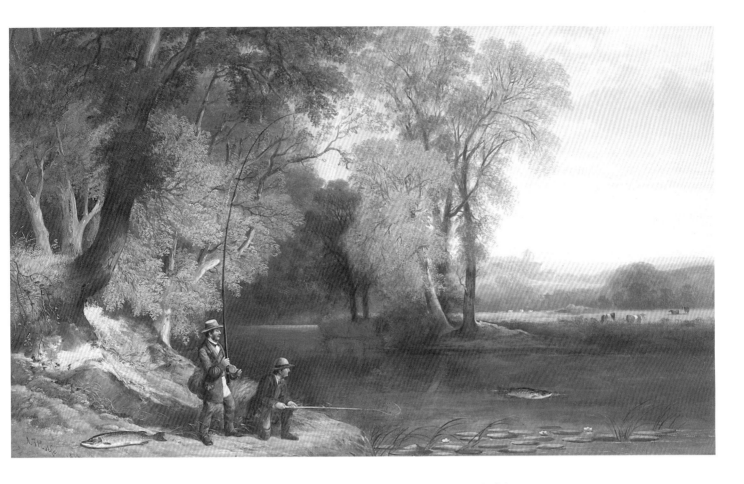

A. F. Rolfe (fl 1839–1871), *River landscape with anglers pike fishing.*

PLATE 5

A carved and painted wooden salmon trophy, 1824.

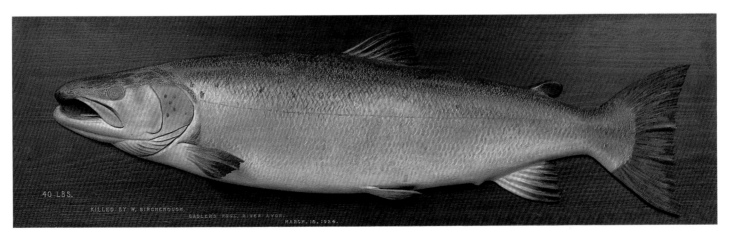

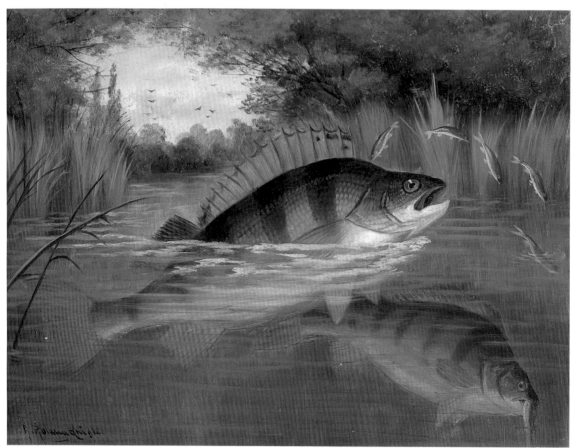

A. Rowland Knight, *First Come, First Served* and (*below*), *Lost by a Head*.

PLATE 6

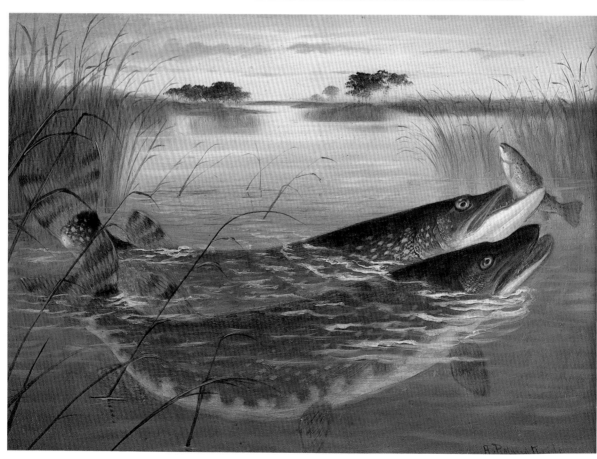

PLATE 7 A. Rowland Knight, *Perch chasing Fry* and (*below*), *A Pike taking a small Roach*.

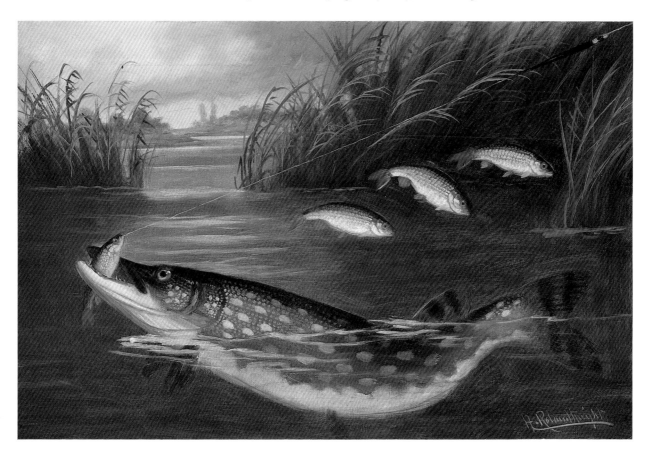

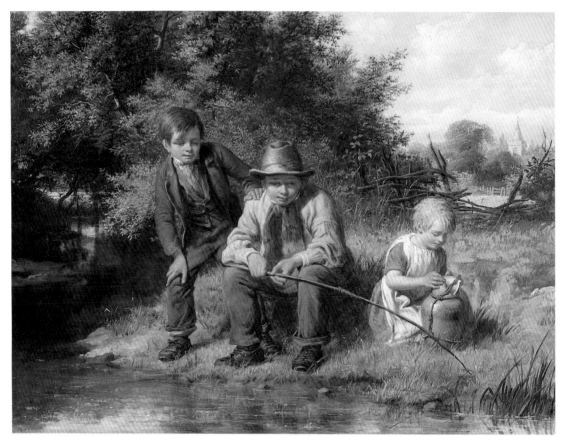

PLATE 8 (*above*) William Bromley (1835–1888), *Three Children Fishing from a River Bank*.
(*below*) Alfred Fontville de Bréanski, Snr (1852–1928), *Angler and cattle by a Loch*.

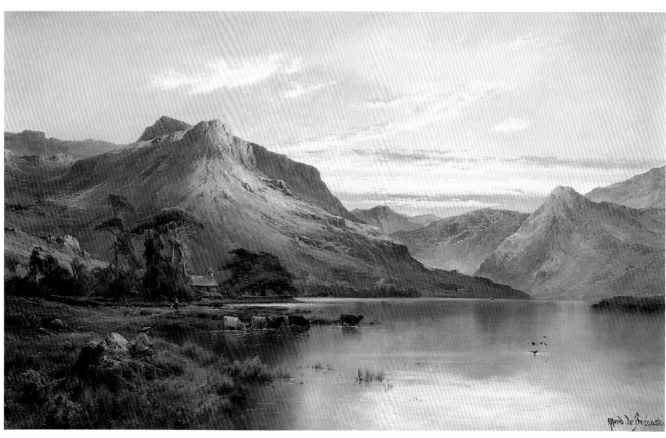

attractive if a little lacking in accuracy so far as the technical depiction of angling is concerned.

The Irish painter Francis Walker (1848–1916) also allows enthusiasm for action to get the better of judgement in his *Salmon Fishing* published in 1866. Here the angler appears to be having a wrestling match with his rod as well as a battle with a hooked fish.

Angling in art has never, of course, been confined entirely to one part of Britain. Even at the height of the sporting enthusiasm for Scotland a number of painters continued to produce interesting, attractive angling landscapes based in different parts of England. John Mulcaster Carrick (at work between 1854 and 1878) is a case in point. Carrick was a talented, if minor Pre-Raphaelite painter who specialised in landscapes, particularly along the Thames. His *Kew Bridge* is a beautiful, light-filled work, skilfully composed and executed. The distant tower echoes the mast of the two barges and in the middle distance are two, almost indistinct anglers. Although this is both more and less than an angling picture pure and simple, it has an early morning, misty feel that is entirely in keeping with the atmosphere of coarse fishing. And the two anglers are an essential part of the landscape. They may be faint, but they somehow

Francis Walker, *Salmon Fishing*, 1886.

73

John Mulcaster Carrick, *Kew Bridge*, 1884, and (*below*) *Isleworth Eyot. The Fishing Pavilion, Syon Park*, 1889.

add a still, quiet quality to this picture of a windless, misty day. Their stillness and the stillness of the rest of the picture contrasts with the tiny movement of the man right at the front of the picture who appears to be painting or cleaning the side of one of the boats. Carrick painted several other views along the Thames that include anglers and his ability to capture the broad effects of light is nowhere better seen than in *Isleworth Eyot. The Fishing Pavilion, Syon Park*, painted in 1889.

One of the founders of the Pre-Raphaelite movement, John Everett Millais (1829–1896), was a keen sportsman who occasionally drew angling pictures – a good example is his sketch of the art critic John Ruskin fishing from a small boat in the Highlands with his wife, Effie.

Alfred Fontville de Bréanski Jnr (1877–1945) also painted anglers along the Thames. His work is more impressionistic than Carrick's, but his anglers are no less part of the scene. De Bréanski's work is sometimes confused with that of his father, also called Alfred (1852–1928), who specialised in Highland landscapes, but as his picture of an *Angler and Cattle by a Loch* reveals he was more intent on portraying the gentler, contemplative side of fishing in the Highlands than many of his contemporaries (*see Plate 8*). Both de Bréanskis used particularly rich colouring in their work, which is often exceptionally well drawn.

Alfred Fontville de Bréanski, Jnr, *The Thames at Kew*.

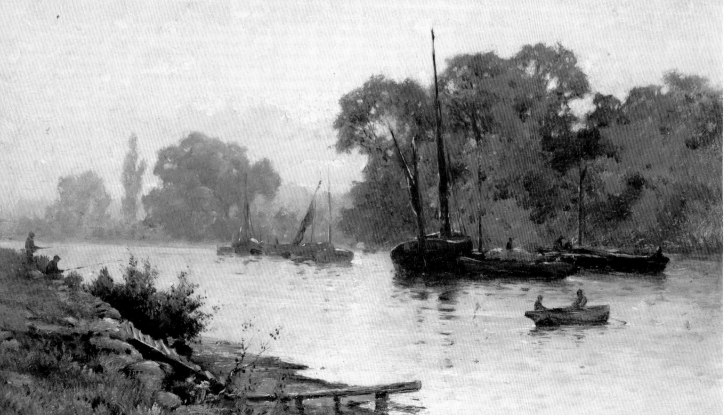

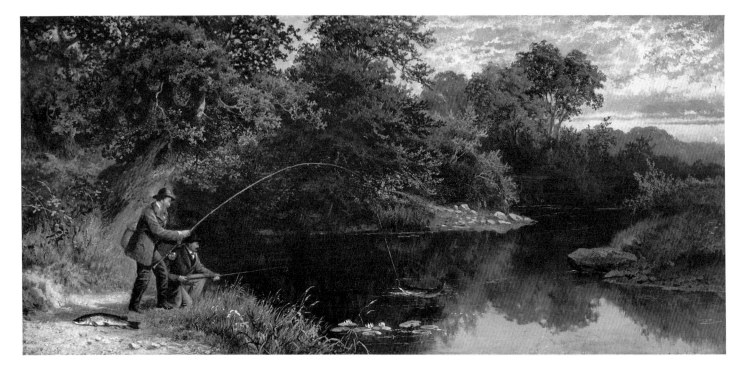

A.F. Rolfe, *Playing a pike*.

I have left the most interesting angling artist, or artists, of the Victorian period until last in this account of the development of angling in art in the nineteenth century, for two reasons. First, little is known about the artists concerned and, second, they were undoubtedly the most prolific and specialist of all angling artists.

The Rolfes were a large family of painters who worked mostly in the latter half of the nineteenth century. The best known member of the family is probably A.F. Rolfe who exhibited extensively between 1839 and 1871. His dates of birth and death are not known, but he worked in Wales and in the South East, particularly in and around Surrey. He produced a large quantity of pictures of fish – clearly painted to be of interest to the angler – together with a number of distinctive and very attractive angling scenes. Typical of his work is his *River landscape with anglers pike fishing* (*see Plate 5*). A.F. Rolfe is known to have occasionally collaborated with the painter J.F. Herring.

Henry Leonidas Rolfe, a close relative of A.F. Rolfe, was a keen member of the Piscatorial Club which still exists today. In the society's club house, at Lower Woodford in Wiltshire, there is a portrait of H.L. Rolfe (believed to be a self-portrait) and it shows him painting a still life of a salmon. The picture gives a tantalising glimpse of one of the best specialist angling painters of the Victorian era whose paintings of fish are the best we have from the nineteenth century. H.L. was probably the most prolific

A.F. Rolfe, *Weighing the catch*, and (*below*) *Fishing scene*, 1855.

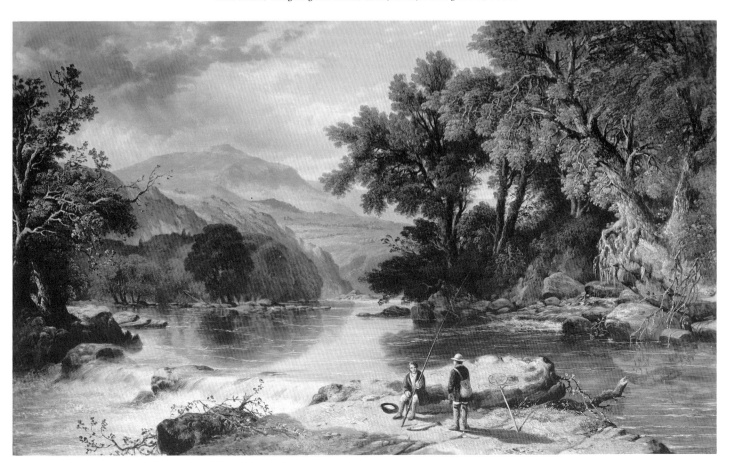

H.L. Rolfe, *Self-Portrait*.

(*below*) Alfred Corbould and H.L. Rolfe, *Fishing scene*, 1862.

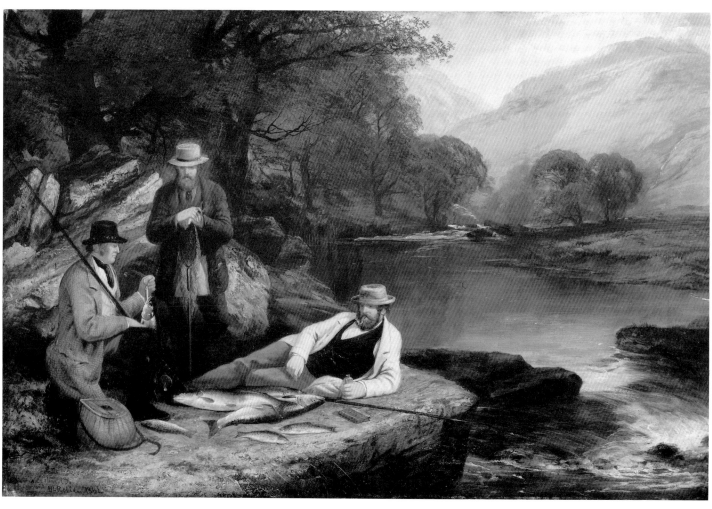

of all the Rolfes, exhibiting more than 115 works at the Royal Academy, the Royal Society of British Artists and the British Institute. He occasionally collaborated with the painter Alfred Corbould.

Two other shadowy Rolfes are known to have painted angling and fish pictures: Edmund whose dates are not known, but who also painted birds, and F. Rolfe who was certainly working between 1849 and 1853. He painted a view on the Wye, and a number of fish pictures. He also painted carved, wooden fish. Carved, painted models of fish were popular toward the end of the nineteenth century and though perhaps not quite examples of angling in art, they did require some skill to make and paint (*see Plate* 5). Farlowes of London produced a number of these and they were often painted by one or other of the Rolfes or by Frank Buckland, a noted eccentric and author of angling books.

A.F. Rolfe, *Landing a Pike*, 1864.

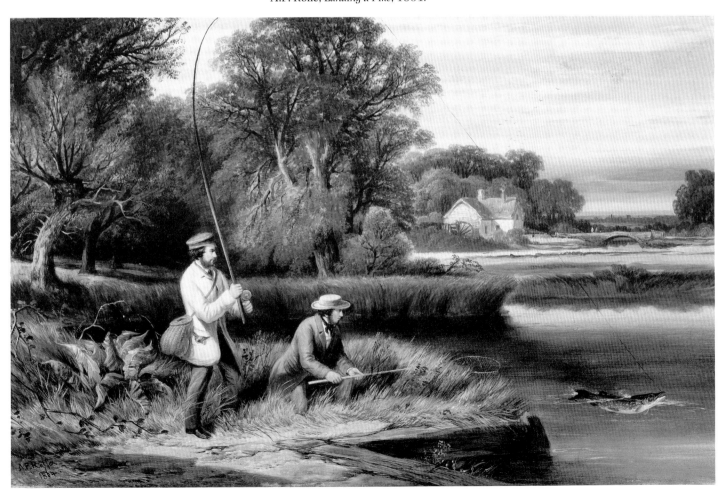

No angler can be a good man
BYRON

5
GLORY IN DIVERSITY
The Early Twentieth Century

Angling painting, like all sporting painting, did not entirely escape the great movements in late nineteenth- and early twentieth-century art. The Impressionists Georges Seurat, Pissarro and Jean Louis Forain painted pictures that include angling and the fish was to appear in some increasingly strange guises as Expressionism and Surrealism gathered momentum. With the invention and increasing popularisation of photography the still life fish painters of the nineteenth century must have found life increasingly difficult, but many landscape painters whose roots lay essentially in the traditions of the late 1700s and early 1800s continued to paint traditional pictures that occasionally involved angling. Mainstream painting found that, increasingly, it could not compete as a realistic or naturalistic method of recording a day's sport – this was now the role of photography, and the modern movement in art had determined on a course largely away from figurative and representational art into the realms of imagination and abstract thought. However, there was a reaction against this. It came to a head with Sir Alfred Munnings' speech to the Royal Academy in 1949 when he said that painters should paint a tree so that it looks like a tree. With those words he dismissed entirely most mainstream twentieth-century art. Angling as a subject for artists has remained very much a traditionalist area.

That said, however, there is as much of interest in the twentieth as in earlier centuries. In a sense the division between the nineteenth century and the twentieth is an entirely unrealistic and arbitrary one. As we saw in the previous chapter many essentially Victorian painters, like de Bréanski, lived on well into the twentieth century (de Bréanski Jnr, for example, didn't die until 1945), and it is probably more accurate

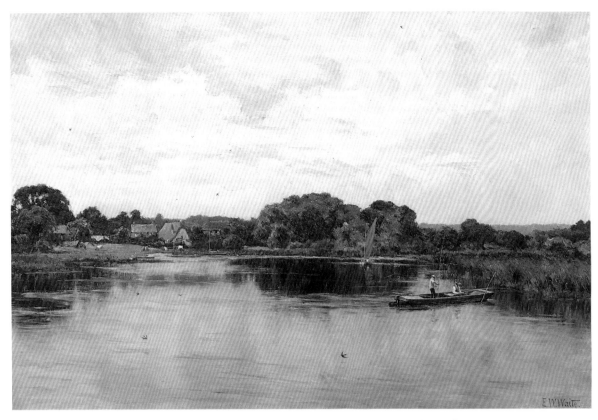

PLATE 9 (*above*) E. Waite (fl 1880–1920), *Riverscape with Anglers fishing from a Punt.*
(*below*) Ernest Edward Briggs (1866–1913), *Hooked! Salmon Fishing on the Innerwick Waters of the Lyon.*

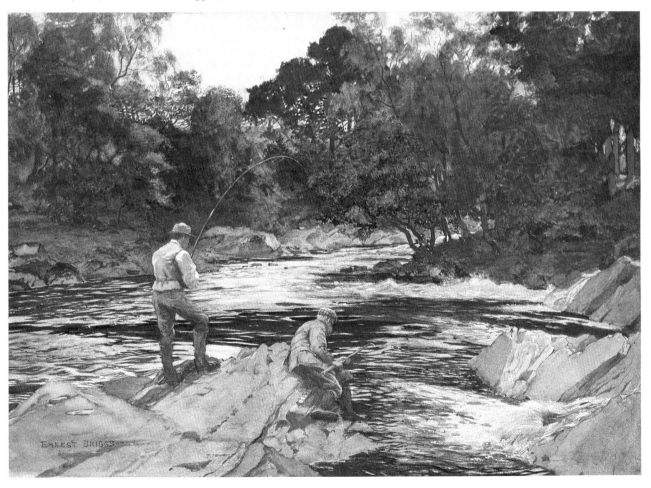

George Denholm Armour (1864–1949), *Coming to the Gaff.*

PLATE 10

Lionel Edwards (1878–1966), *Salmon Fishing.*

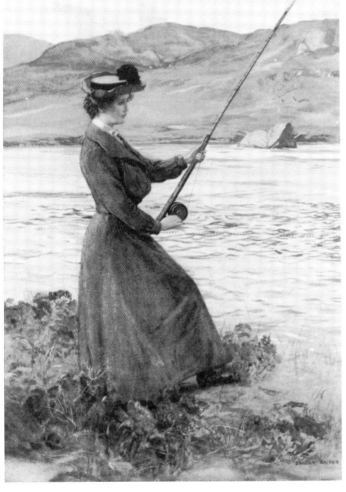

Ernest Briggs, *The Gentle Art*, frontispiece to *Angling in Art in Scotland*, 1908.

to see the First World War as a watershed for art. It is hard to imagine a painter like Ernest Briggs (1866–1913) as other than essentially Edwardian. Briggs was so keen on fishing that he would probably have described himself as, first, an angler, and second, a painter.

However much of a traditionalist he may seem, he is that rare creature: a professionally trained and highly skilled painter who managed to embody technical and dramatic accuracy in his angling pictures. Briggs was born at Doughty Ferry in Scotland. He studied at the Slade School (1883–7) after giving up a career as a mining engineer on the grounds of ill-health and he painted landscapes, genre subjects and a large number of angling pictures. From 1889 he exhibited regularly at the Royal Academy and at the Royal Society of British Artists. Among anglers he is probably best remembered for his book *Angling and Art in Scotland*, published in 1908. The book describes the pleasures of painting in Scotland and the difficulties of concentrating on art when good fishing was always a mere cast away. Briggs' output was relatively small, but a typical example of his work would be his *Salmon Fishing*. Here an angler is playing a salmon from a boat in the middle of the river. The salmon on the other end of his line has just leapt near the bank in the foreground of the picture. The attitude and

81

positioning of the angler are perfect and the fish leaps just as a played fish would leap. Briggs, who often worked in watercolour, was a skilled draughtsman with a good eye for light, particularly as it plays on water, and *Salmon Fishing* is certainly a splendid, living picture (*see jacket illustration*). Another good example of his work is *Hooked! Salmon Fishing on the Innerwick Waters of the Lyon* (*see Plate 9*).

Lionel Edwards (1878–1966) lived far longer into the twentieth century than Briggs and though he is best known as a painter, mostly in watercolour, of horses, hunting and historical subjects, he did occasionally turn his eye, and a most skilful hand, to angling. His *Salmon Fishing* study is very much an illustration in terms of style and composition (*see Plate 10*). It would please the most fastidious angler, however, on the grounds of technical accuracy. The fish is being played just as it would be in a real situation, but compared to Briggs' painting this has a flatness, a lack of sparkle. With its broad flat areas of paint the picture is also far removed from the Edwardian style of Briggs. Edwards studied under A.S. Cope and another well known twentieth-century sporting artist, Frank Calderon.

George Denholm Armour (1864–1949) is very much part of this school of Edwardian painter/illustrators who clung to the traditions of the past. Armour drew pictures for *The Field* magazine, *Punch* and the *Illustrated London News*, but he was also an accomplished painter. He studied in Edinburgh at the Royal Scottish Academy Schools before moving to London where he exhibited at the Royal Academy between 1884 and 1928. Many of his pictures are humorous, but *Coming to the Gaff* is a typical example of his work. It shows the last moments of a battle with a good salmon; the gillie is about to gaff the fish and the angler – a study in concentrated effort – is playing it as carefully as he can. In terms of composition there is little to be said about the picture: there is no attempt to create a picture that works as a whole, all the energy and emphasis is centred on the angler, the gillie and the fish. The landscape in the background is barely sketched in, but, ironically, this adds to the power of the central image since we are given no other distracting details or areas of interest (*see Plate 10*).

The comic, or at least lighthearted aspects of angling, still attracted a number of late Victorian and Edwardian painters like Armour. Walter Dendy Sadler (1854–1923) is a particularly good example, and though he was not well known as an angler he painted a number of interesting and highly amusing pictures. His *Pegged-Down Fishing Match* is a wonderful satire on the superficial absurdities of match fishing where anglers line out along the bank at thirty yard intervals to catch as many fish as they can, only to throw them back at the end of the day. Sadler's other angling pictures include one of the most reproduced of all angling images: his *Thursday – Monks Fishing* has been used on countless postcards and prints. He also painted *It's Always the Largest Fish that's Lost* (1881), *A Goodly Catch* (1884) and *Gudgeon Fishing* (1885). Sadler was

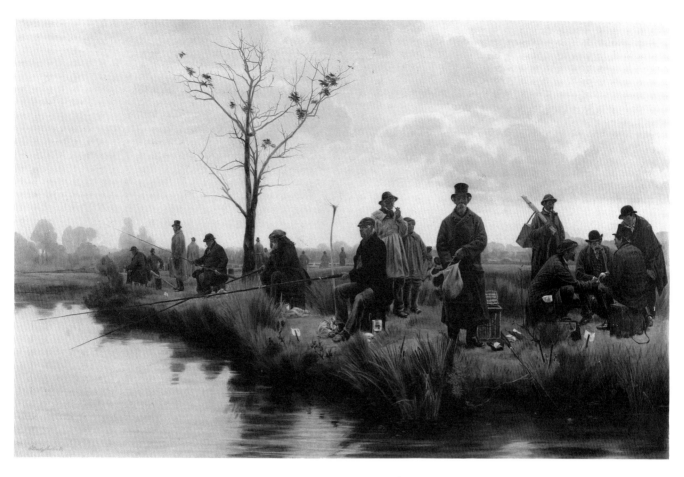

Walter Dendy Sadler, *Pegged Down Fishing Match*, 1885, and (*below*) *Thursday – Monks Fishing*.

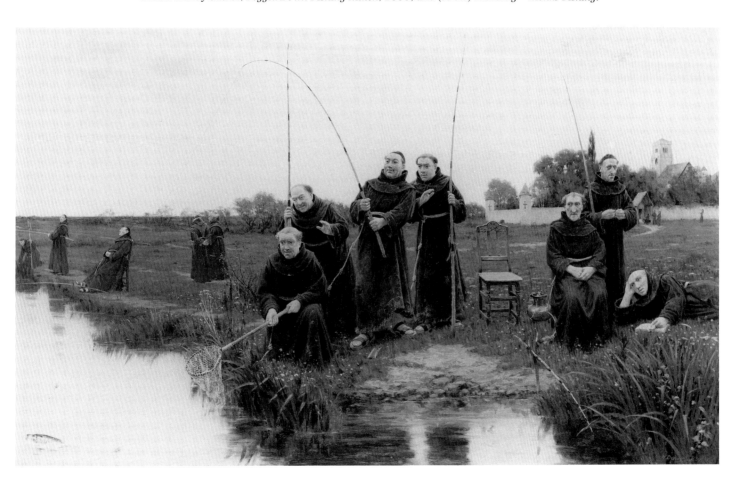

Walter Dendy Sadler, *On the Way to Fish*.

adept at painting coarse as opposed to game fishermen and he went to some pains to emphasise what he obviously saw as their static, rather dogged attitude to their sport. Not for the coarse fisherman the pleasures of wandering the river bank looking for a rising fish. Instead the coarse fisherman is portrayed, at least by Sadler, in a way that indicates he is addicted to the slow, seemingly endless task of sitting still in one position on the river bank. Sadler's *On the Way To Fish* is something of a departure from this formula. Painted in 1880, it shows a wary, portly angler gazing suspiciously out from the canvas as he makes his way along the river bank. The intention of the picture, as with all Dendy Sadler's work is to portray the angler as a harmless, but rather comic figure – a view with which many anglers would agree.

Women anglers figure in the work of one or two early twentieth-century painters. Ernest Briggs painted women anglers, but somehow the Victorians seem to have felt that angling, like many sports, was rather a rough pursuit for their idealised conception of women. In a sense then the return of women to angling pictures at the turn of the century marks a return to at least one aspect of eighteenth-century painting, where women and their families, as in Hogarth's *The Fair Angler*, are once again fit subjects for the painter. The reappearance of women in angling pictures was also part of a general resurgence of portraiture, particularly in the work of Lavery and John Singer Sergeant.

George F. Carline (1855–1910) painted his delightful portrait of his wife fishing on the Cattent River in Surrey in 1896. The picture has a remarkably relaxed air which is emphasised by the flat calm around the punt and by the fact that the woman isn't even holding her rod. It is as if she is entirely mesmerised by the limpid water into which she is staring. The picture has an almost nostalgic feel as if the angling aspect

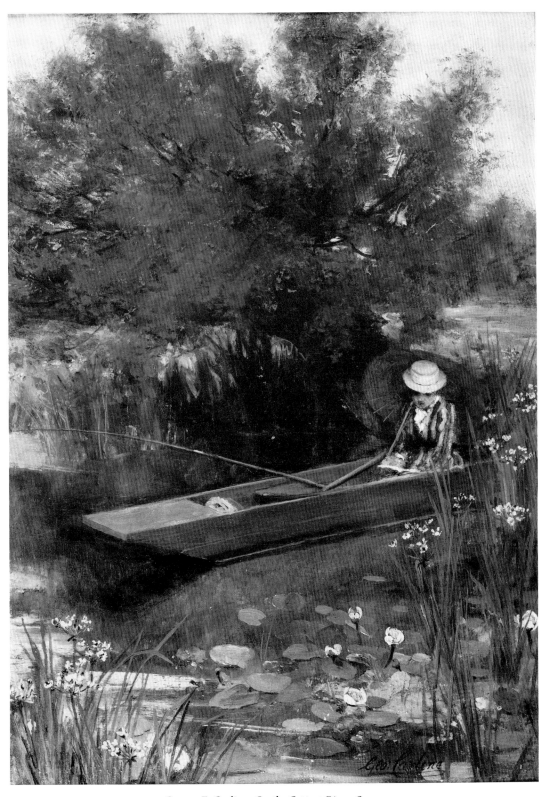

George F. Carline, *On the Cattent River, Surrey.*

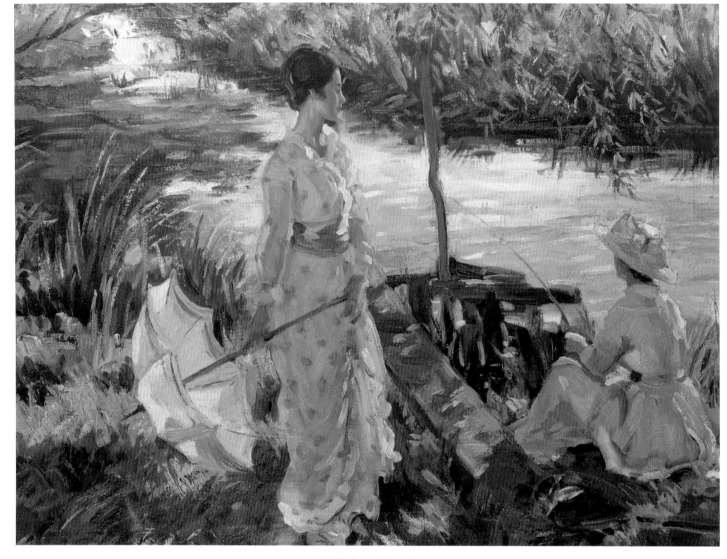

Wilfred de Glehn, *Fishing*.

is there to give the portrait a flavour of long, dreamy summer days that exist only in the memory.

The identification of angling with idyllic days is a vivid aspect of Wilfred de Glehn's *Fishing*. This vaguely impressionistic picture uses angling to emphasise the carefree nature of the two women and it is stylistically far removed from the work of an artist like Briggs. De Glehn, who was born in London in 1870, studied at the Royal College of Art and at the Ecole de Beaux Arts in Paris. He exhibited at the Paris Salon in 1891 and at the Royal Academy from 1896. He travelled widely in Europe and America and the influence of his travels is clear in his painting which, with its emphasis on light and form, is very different from the work of Briggs or Armour.

Another painter much influenced by Impressionism and trends outside the narrow teaching of the English art schools, was John Singer Sergeant (1856–1925). Both de Glehn and Sergeant were members of the New English Art Club, founded in 1886. The club represented the interests of a number of men who had studied abroad, particu-

larly in Paris, and who wished to escape what they saw as the restrictions and lack of freedom in English art. Such was the revolutionary nature of the work of the club members and, conversely, the conservatism of the art establishment in England that the Club's first exhibition, organised under the eye of an established dealer, was cancelled once the dealer laid eyes on the exhibits.

It is difficult to see now what all the fuss was about. Apart from a study of nude boys by Tuke, the paintings mostly merely had a free, broader use of paint, a more impressionistic style. Sergeant, though of American parentage, lived much of his life in England. He painted a number of angling pictures after visiting Norway and his *Portrait of a Young Salmon Fisher* is an excellent example of his skilful composition and free style. Sergeant also painted one or two still lifes of fish, together with his portrait, *Mrs Ormond Fishing*. Here the angling aspect of the picture is minimal, but the fact that she is fishing gives Singer the chance to portray her against a background of dappled light on water and in a pose that is abstracted in a way that most anglers would instantly recognise.

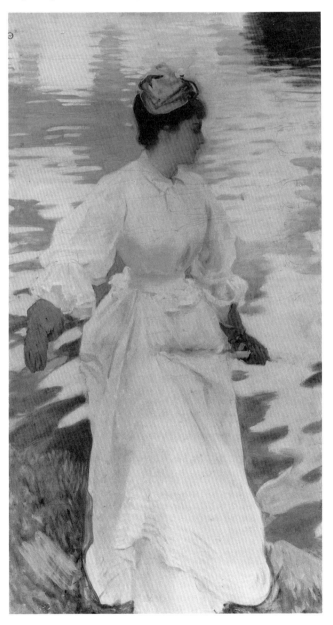

The increasing influence of Continental styles of painting, though it produced a reaction in artists of the Munnings School, transformed the work of a number of British artists, including Joseph Crawhall (1861–1913), a member of the Glasgow School and a keen angler. Crawhall's father (see Chapter 8)

John Singer Sergeant, *Mrs Ormond Fishing*, 1889.

87

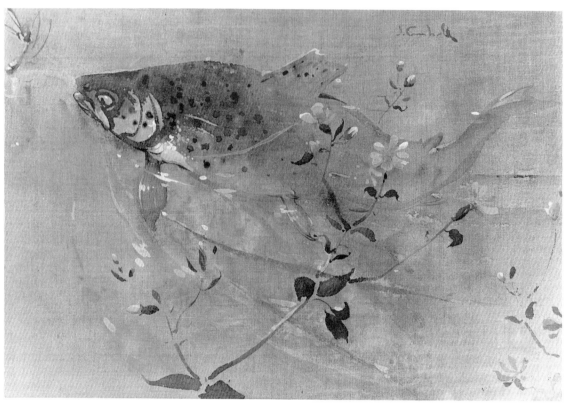

Joseph Crawhall, *A Trout Rising.*

Stuart Park, *A Slippery Subject.*

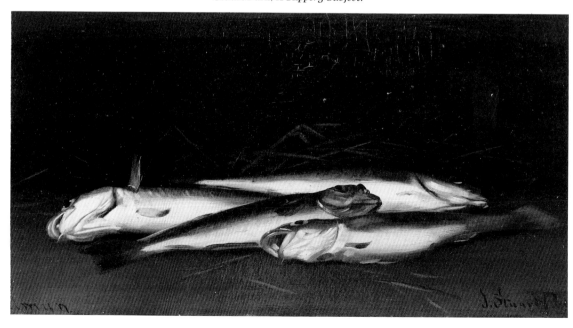

had also been a keen angler and amateur artist, but the younger Crawhall gave a new power to watercolour painting. He was predominantly a painter of animals and birds, but if in subject matter he had much in common with many other artists of the late Victorian and early Edwardian period, he had little in common with their techniques. Like Sergeant and de Glehn he reacted against the detailed and minutely finished pictures of many of his contemporaries. His *Trout Rising* gives a wonderful sense of his ability to create an impression of life and movement through his exquisite use of line and colour.

Stuart Park (1862–1933) was another member of the Glasgow School. Like Crawhall he studied in Paris, but he is best known as a flower painter. He did, however, produce an interesting still life of sea fish. His picture *A Slippery Subject*, though not strictly speaking an example of angling in art is interesting because it depicts sea fish much as coarse and game fish were portrayed during the nineteenth century. Sea angling and sea fish are almost entirely absent from the work of all other British painters, certainly until this century.

The reaction against the free use of paint, with its broad brush strokes and emphasis on shapes and patterns of colour took place in England after the outrage caused by the French Impressionists. The dislike of anything perceived as modern has always been strong in British painting and the reaction at its strongest is perhaps typified by a picture like Frank Moss Bennet's *An Angler outside the George and Dragon*. The picture is one of pure nostalgia for a vanished and fictional past of rustic, hearty types outside English ale houses in a world of innocent long ago (*see page 90*). Even the style of the painting harks back to previous centuries. Bennet, who was born in 1874 and died in 1953, specialised in scenes of merry England.

A more interesting painter and one who more or less assimilated the lessons of the Impressionists and yet retained a curiously traditional feel is the marine and angling painter Norman Wilkinson (1878–1971). Wilkinson painted many excellent angling scenes. He had a genuine feel for the sport and for the effects of light and shadow upon land and water. His was no slavish devotion to the traditions of the past – except perhaps so far as composition is concerned, but then he was clearly determined to portray an element of realism in work that essentially gives an impression, without obsessive academic attention to detail. Wilkinson's pictures are very much part of the twentieth century, yet they are also fine and interesting representations of angling in art.

Wilkinson was born in Cambridge and educated at Berkhampstead and at St Paul's Cathedral Choir School. He started life as a marine painter and etcher. He worked as a magazine illustrator until 1914 when he entered the Royal Naval Volunteer Reserve. Here he turned his considerable painting skills to the war effort and invented

Frank Moss Bennet, *An Angler outside the George and Dragon.*

camouflage for allied shipping. This was originally known as dazzle painting and it earned Wilkinson an MBE. After the war he became marine painter to the Royal Yacht Club, but as a keen angler he continued to paint pictures of his favourite sport. His angling pictures include *Sea Trout Fishing, Loch Shiel*; *A Rising Trout, Fly Fishing*; *The Intake Pool, River Spey*; and *The Disputed Pool, River Awe*.

Like Wilkinson, S.J. Lamorna Birch (1869–1955) was a painter who portrayed angling because it was a sport he loved. Indeed, it has been said that Birch was torn between his love of art and his love of fishing. He painted many angling scenes both in oil and watercolour and was largely self taught. After 1899 he stayed for increasingly lengthy periods at Lamorna in Cornwall. At the suggestion of another local artist, also L. Birch, he added the name Lamorna to avoid confusion.

Vincent R. Balfour Browne (1880–1963) was an Oxford educated painter in water-colour of animals and, occasionally, angling subjects. He spent much of his life in Scotland and was a keen shot and fisherman who exhibited 269 works at the Fine Art Society between 1907 and 1936. What his pictures lack in originality they make

Norman Wilkinson, *Sea Trout Fishing, Loch Shiel*, and (*below*) *A Rising Trout*.

Vincent R. Balfour Browne, *Salmon Fishing.*

up for in technical accuracy. Another shadowy figure who included angling scenes very occasionally in his pictures was E. Waite who worked at Blackheath and Dorking and appears to have been most active between 1880 and 1920. Other than that, nothing is known of him but his *Riverscape with Anglers fishing from a Punt*, is a delight (*see Plate 9*).

Though all the artists discussed in this chapter were working in the twentieth century they are mostly products of Victorian and Edwardian England. It is to the painters and sculptors who were born after the First and Second World Wars that we must now turn to see how angling in art has developed in Britain up to the present day.

As no man is born an artist, so no man is born an angler
ISAAK WALTON

6

A LIVING ART
Contemporary British Painters and Sculptors

Many, though by no means all, the artists discussed in this chapter are alive and working today. Most are aware that they represent a reaction against much mainstream art, but their aim in the main is to produce traditional, representational work. To use Munnings' phrase they have stuck to the idea that if you paint a tree you must make it look like a tree. And this in spite of mainstream art's refusal to take this route on the grounds that representational art is too limiting for the imagination, too much like simple photography.

That said, the artists involved are concerned increasingly to show the fish in its environment, rather than at the end of the angler's line. One or two may concentrate on the fish's environment, or on an unusual angling situation, perhaps showing anglers attempting to follow a hooked fish downstream. The emphasis has been on portraying the fish or the angler realistically, but with some twist or narrative element. Technique tends to be of less importance since the artists involved are keen to portray the thing itself rather than the sense that this is art at work.

Will Garfit (born 1944) is perhaps the most interesting of living angling scene painters in the sense that his riverscapes are not really angling pictures at all. Yet Garfit, a keen angler himself, does paint pictures of rivers from an angler's point of view. When he decided to paint a scene on the Usk, for example, he chose to portray a salmon pool at Gliffaes (*see Plate 11*). A picture of a waterfall on a river will often be given a very specific title, like *Where Salmon Leap*. Garfit was born in Cambridgeshire. He studied at the Cambridge School of Art, Byam Shaw School and at the Royal Academy Schools. His work is fiercely traditional, but technically excellent and he has exhibited

William Garfit, *Boyhood Memories*.

Leonard Applebee, *The Catch*.

widely at the Royal Academy, the New English Art Club and at the Royal Society
of Portrait Painters.

A painter who occasionally depicts angling subjects in a decidedly untraditional
way is Leonard Applebee (born in 1914). Applebee's still life *The Catch*, painted with
flat square brush strokes to create a sense that the picture is almost breaking up, is
highly accurate yet painterly. Applebee, better known for his flower studies, was born
in London and studied at Goldsmith's School of Art (1931–1934) and at the Royal
College of Art (1935–1938).

Few engravers are now working even occasionally on angling or fish subjects, but
Colin Paynton (born 1946) specialises in wildlife subjects including fish. He sees himself
in a tradition going back to Bewick and produces carefully worked images of fish and
wildfowl from his remote Welsh farmhouse. He has exhibited at the Society of Wildlife
Artists and at the Royal Society of Painters in Watercolours. Paynton likes to create

Colin Paynton, *Swallow, Chub and Watery Dun* (*left*), and (*below*) *Pintail and Grayling.*

Neil Dalrymple
(b 1949), *Sea
Trout*.

PLATE 11

William Garfit (b 1944), *The Salmon Pool at Gliffaes, River Usk.*

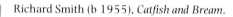
Richard Smith (b 1955), *Catfish and Bream*.

PLATE 12

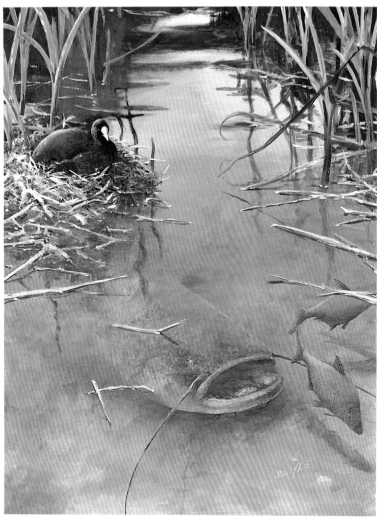

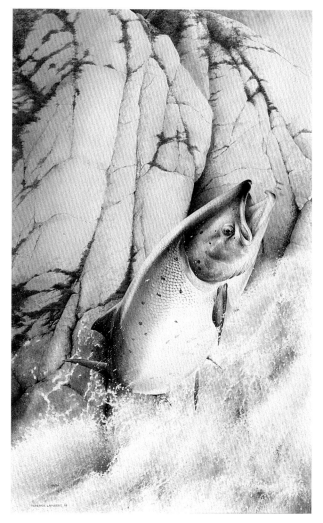

Terence Lambert (b 1951), *Leaping Salmon*.

multiple layers in his wood engravings and typical of his fish pieces are *Pintail and Grayling* and *Swallow, Chub and Watery Dun*. Although both works faithfully produce the dominant characteristics of the species they portray they also have a pattern of line and light that gives them an almost abstract feel.

Perhaps rarer even than engravers among the angling artists are the sculptors. David Hughes (born 1949) covers the whole range of fish species, as well as coarse and game fishermen. Among his most striking pieces cast from resin-bonded metal with a bronze finish is *The Winning Team* – two anglers boat fishing for trout and one about to land a fish. Many of Hughes' pieces are commissioned by angling organisations or publications. *Angling Times*, for example, commissioned his splendid piece, *Billy Lane*, a portrait of one of Britain's best known match fishermen. Hughes, the son of the painter Derrick Hughes, was educated in Warwickshire. He established his own studio in 1981 after studying in a fine art studio run by a family friend, the Birmingham born sculptor

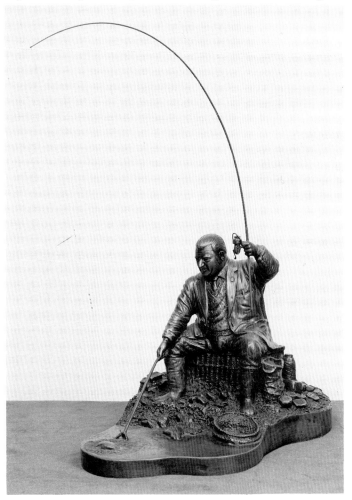

David Hughes, *Billy Lane*.

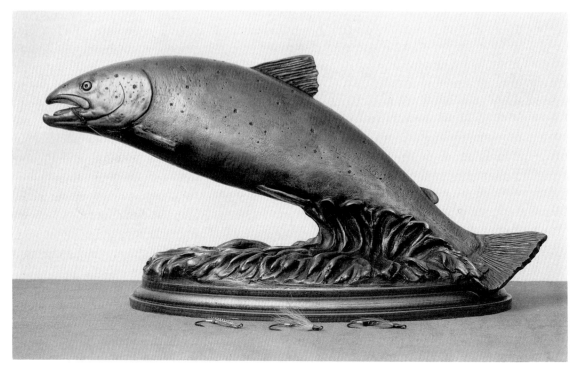

David Hughes, *Salmon Study*.

John Letts. Hughes' work attempts to be as detailed and realistic as possible – even down to using real nylon fishing line.

Another sculptor known for his portrayal of fish is Neil Dalrymple (born 1949). A member of the Society of Wildlife Artists, Dalrymple spent a number of years working in Canada before returning to Britain in 1985. Like Hughes he is keen that his work – his *Sea Trout* ceramic is a good example – should be as naturalistic as possible (*see Plate 11*).

Perhaps the best known British painter and illustrator of angling subjects is Rodger McPhail who has cornered the shooting and fishing art markets, particularly through his work for various specialist magazines and through his two books, *Open Season* and *Fishing Season*. He has also exhibited regularly at the Tryon Gallery in London. His books are collections of his shooting and fishing illustrations. McPhail was born in Lancashire in 1953. He studied at the Liverpool School of Art and has painted in Spain and the United States. He is a keen angler and has illustrated a number of books including Lord Home's *Border Reflections* and Aylmer Tryon's *The Quiet Waters By*.

McPhail's work is solid and traditional and it works best when it is anecdotal: his *Fish Going Down the Rapids* is a case in point. Two anglers are desperately trying to follow a hooked salmon as it makes for the rapids. The problem is that they must

Rodger McPhail, *Fish Going Down the Rapids*.

pass the rod around numerous trees in order to keep up with the fish. The suspense of the moment is held forever in the painting because we cannot know the outcome of the battle. A more unusual painter/illustrator is Robin Armstrong. A Londoner by birth he always longed to live and work in the countryside and now works as a riverkeeper in the West Country. He paints the flowers, fish and birds of the river environment and is an avid conservationist. Armstrong's pictures are romantic and vaguely impressionistic, but they are skilfull and accurately drawn, and he often works on coloured papers. In 1985 he wrote and illustrated *The Painted Stream*, an account of his life and work as a riverkeeper.

A keen angler who almost never paints angling scenes, but is highly skilled at painting the angler's quarry is Richard Smith. Smith (born 1955) has a superb eye for detail and can create a picture of a trout hovering over gravel that has an almost abstract quality. His work rarely attempts simplistic naturalism. His *Catfish and Bream*

Robin Armstrong, *Brown Trout*.

is a good example of his skilled use of colour and ability to create a sense of depth and mood (*see Plate 12*).

Terence Lambert (born 1951) is an almost fanatical angler who also paints. He studied at the West Surrey College of Art and Design and has illustrated numerous books, including *Fishing in Wild Places* by David Street. A fisherman since childhood, Lambert has established a reputation for bold, dramatic works, like his *Leaping Salmon* (*see Plate 12*), and for being able to catch fish under the most difficult conditions.

Charles Jardine (born 1953) has the lightest touch of all the angling artists working in Britain today. Using pale washes and little detailed brush work he creates water-colour drawings of an unusually limpid beauty. Like many contemporary British angling scene painters he is a keen and highly skilled angler, who often works as an illustrator for *Trout & Salmon* magazine (*see Plate 13*). Jardine studied at the Canterbury School of Art and has illustrated more than a dozen books.

Keith Hope Shackleton was born in England in 1923, but his family soon moved to Australia where he received the first part of his education. Back in England at the age of five he was sent to Oundle School in Cambridgeshire where his interest in wildlife began. After school and then war service he travelled extensively while working for the family aviation firm and he became a champion dinghy sailor, on one occasion crewing the winning boat in the Prince of Wales' Cup. Shackleton worked for the British television series 'Animal Magic' and is now a full-time painter and illustrator.

Principally a marine painter and by no means exclusively of fish, Shackleton produces work with a decidedly New World flavour (*see Plate 13*). Like American angling and fish painters he is interested in big game fish; the swordbills and marlins of distant seas, and he takes us nicely into the last category of angling scene painters: the Americans.

Winslow Homer, *The Cast*, 1894.

I love discourse of rivers, fish and fishing
ISAAK WALTON

7

THE NEW WORLD
Angling in Art in America

The traditions of fish painting and angling in art in the USA are vastly different from those in Britain. The Americans' early isolation from European mainstream art and their openness to new ideas affects all areas of American culture including, of course, art. There is also an immense difference of scale – American painters of angling and fish subjects are not so tied to the idea that freshwater angling is the only fit subject for the artist. In America, the power and fury of big game fish captures the imagination of many angling painters. This is particularly true of recent years during which a policy of catch and release has gained favour with American anglers. Instead of taking home their fish, the American angler often commissions a painting of his battles with the giants of the deep.

American painters of freshwater angling subjects concentrate almost exclusively on game fish, but of course in the USA this definition includes a number of species, freshwater bass, bluegill and so on that we do not have. Few American artists would paint pictures of, say, the carp, since in many areas of the United States the fish is considered to be simply a pest.

The earliest serious painter of angling subjects in American art history also happens to be one of that country's truly great original artists: Winslow Homer (1836–1910). Homer was born in Cambridge, Massachusetts and at nineteen was apprenticed to John Bufford, a lithographer in nearby Boston. Homer's earliest work was wood engraved illustrations for magazines like *Harper's Weekly*. By 1859 he was making a living as a freelance illustrator. He covered the American Civil War, concentrating

103

on pictures of camp life; his picture, *Prisoner from the Front*, showing Southern prisoners standing before a Union officer was his first really successful painting.

With the war over, Homer began a life of increasing personal and artistic isolation. Like the group of American artists of an earlier generation known as the Hudson River landscape painters (the most famous member of the group was Thomas Cole (1801–1848)), Homer travelled through New England during the spring and summer, painting, fishing and hunting. Then, back in his studio in winter he turned his summer watercolour sketches into fully realised oils.

Homer spent a year in France and several years on Tyneside in the north of England. The latter experience affected him greatly. He had been fascinated by the lonely, dangerous lives of the fishermen of North America and in the north of England he found a similar race of tough, enduring men and women.

These experiences all contributed to Homer's greatest paintings which are invariably scenes of man pitted against nature. Where Homer's earliest paintings show youngsters sailing against light, billowy skies, the paintings of his maturity show darker more brooding elements that threaten continually the human figures whose presence is revealed only by a few striking patches of light in an otherwise dark composition.

Groups of figures, though relatively common in Homer's early seascapes, are rare in his later works. In *The Fog Warning* we see a lone fisherman battling home (with a big halibut in the bottom of the boat) as sea and sky threaten. Apart from pictures like this, of men fishing for a living, Homer also painted brooding and most impressive studies of freshwater anglers. His series of watercolours painted on graphite, *The Lone Fisherman*, *The Rise* and *The Cast* are utterly un-European and although the angler is the central figure in each, there is an enormous sense of his being a tiny speck of humanity in a vast, dark and largely unexplored world. There is no sense in these pictures of the gentle nature of angling in England. Homer is aware that this is an angler in a wild, untamed country. The tradition that fed the idea of angling as a gentle, contemplative recreation is entirely missing from these pictures. Instead, in the brooding darkness and impenetrability there is a sense of futility, of the angler as a tiny, anonymous part of nature.

Homer was a keen angler who fished for much of his long life, but as he grew older he became increasingly anti-social, working alone for months at a time in a studio in a remote fishing village in Maine. He painted commercial fishermen and anglers because these were the subjects that interested him, but they also represented what were for him fundamental truths about man's role and place in the world. In this sense Homer is unique among American painters of angling subjects.

In the world of commercial art, America has produced at least one remarkable artist who was drawn often to angling subjects. Norman Rockwell (1894–1978) is probably

Charles Jardine (b 1953), *Rainbow Trout following a Fly*.

PLATE 13

Keith Hope Shackleton (b 1923), *A Broadbill Swordfish*.

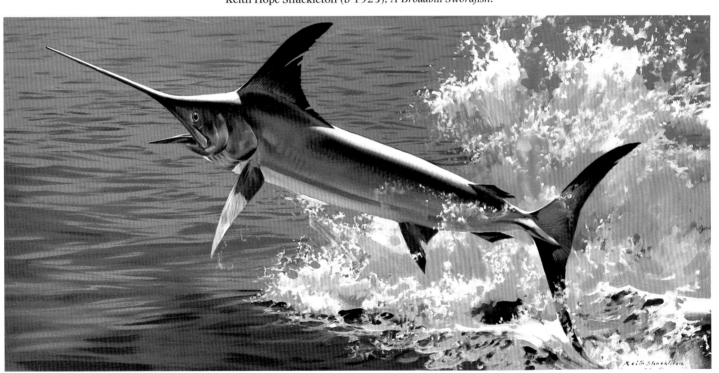

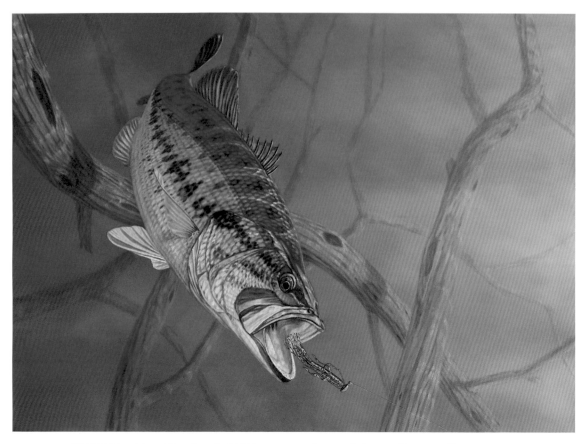

PLATE 14 (*above*) Don Ray (b 1958), *Largemouth Bass*. (*below*) William Coadby Lawrence,
Leaping Tarpon.

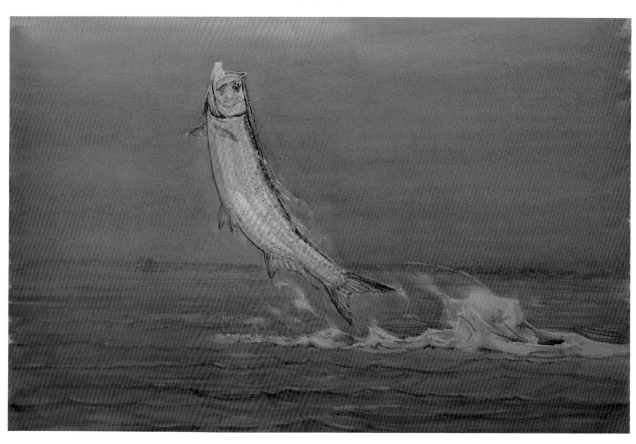

PLATE 15 Michael Ringer (b 1948), *Icy Drift* and *Quiet Water Beaverkill*.

PLATE 16 (*above*) Virgil Beck (b 1955), *Prowling Brookie*. (*below*) Philip Murphy (b 1947),
Trout Leaping.

Winslow Homer, *The Lone Fisherman*, 1889, and (*below*) *The Rise*, 1900.

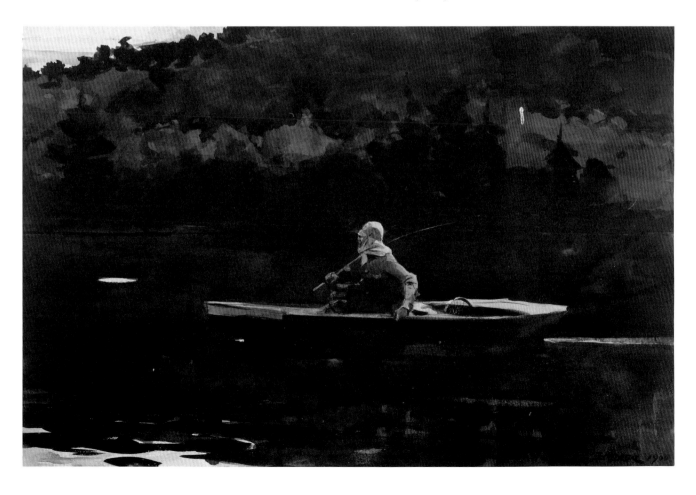

Norman Rockwell, *The Saturday Evening Post*, 19 April 1939, and (*below*) Advertisement for Fisk tyres.

best known for the series of covers he painted for the *Saturday Evening Post* in the 1920s and 1930s, but he was also one of the best loved painters of ordinary American life. One angling cover (19 April 1939) for the *Saturday Evening Post* draws on the age old idea that anglers are a pretty comic bunch prepared to sit out in all weathers in the name of sport. A very different use of angling in Rockwell's art occurs in his advertisement for Fisk bicycle tyres. Here, angling is tied in closely with the image of youthful health and energy – we see the all-American boy about to set off (on his Fisk tyres) for a wholesome day's fishing.

Stanley Meltzoff (born 1917) is probably the best known American painter of marine wildlife today. He describes himself as a traditional 'optical naturalist' who tries to paint what he sees or imagines he would see if he were underwater with the fish he paints. Meltzoff says he attended a number of art schools, but is largely self-taught. A former teacher and prolific illustrator he now paints large oils of underwater scenes. He has even been known to set his easel up at the bottom of the ocean and to paint in that position (suitably kitted out with full diving gear).

Meltzoff's pictures are dramatic and uncompromising, with titles like *Bluefin Busting Mackerel* (this shows a massive bluefin smashing its way through a shoal of mackerel). He is concerned to show nature red in tooth and claw. His angling pictures include *The Master and his Sailfish*, *Gaffed*, and *At the Boat*. Meltzoff has no sentimental view of the world he paints and he has no qualms about painting the violence of big game fish and big game fishing.

William Coadby Lawrence, a near contemporary of Meltzoff's is a keen angler and professional artist. He works in Maine where Winslow Homer spent so many years, and has illustrated a number of books on sea angling. Several of his paintings of big game fish have been published as limited edition prints. A typical example of his work is *Leaping Tarpon* (see Plate 14).

John Carroll Doyle (born 1932) studied journalism at the University of South Carolina but is largely self taught as an artist. He describes himself as a nineteenth-century artist stuck in the twentieth century. He paints almost exclusively in oils and a typical example of his angling work is a picture like *Sailfish Leaping for Freedom*. Here a big sailfish breaks the surface in the foreground of the picture while in the distance we see the angler and his companions aboard their boat. Like Meltzoff and Coadby, Doyle's main aim is to present the angling scene as dramatically and realistically as possible, but from an angle that would be virtually impossible for a photographer. When he isn't painting big game fishing scenes, Doyle paints everyday scenes along the coast of his native South Carolina. These pictures include commercial oystermen, shrimpers and scenes at the docks.

Michael Ringer (born 1948) studied at the Rochester Institute of Technology and

Michael Ringer, *Casting to a Big Rise*.

at the University of Buffalo. He specialises in painting angling scenes along the St Lawrence River in New York State. His work is solidly traditional, and it harks back to the work of Winslow Homer in the sense that it captures the scale of the landscape in which the angler finds himself. Tiny figures appear in broad, treelined rivers with no sign of human habitation. Ringer describes himself as a realist who works in oils, watercolours and acrylic. He is also a sculptor.

Many of Ringer's landscapes, particularly *Quiet Water Beaverkill* (*Plate 15*) and *Casting to a Big Rise* could have come straight out of the nineteenth century, but they are none the less popular for that. His work has appeared in many American magazines and journals and in his angling pictures he is clearly concerned to create the atmosphere of a day's fishing, rather than the drama of playing a fish. In this respect he differs markedly from the big game artists who dominate the American scene. In *Casting to a Big Rise* it is the weather – thickly falling snow – we notice most, while in *Icy Drift* (*Plate 15*) the stillness of an extremely cold day is perfectly captured through the stiffness of the figures, the mist and the steely colours.

Don Ray (born 1958) describes himself as a realist. He works almost exclusively

in oils and paints pictures of great dramatic power. Although he rarely paints angling scenes as such, he believes that many of his fish paintings are bought by anglers. Like the other American angling and fish painters working today, his main concern is to make his fish look as naturalistic as possible. The level of vivid realism he achieves can be seen clearly in a picture like *Largemouth Bass*. Here one of America's most popular game fish is seen chasing an angler's lure against a background of sunken trees (*see Plate 14*).

Virgil Beck (born 1955) studied fine art at the University of Wisconsin. He has produced pictures for American stamps and for a number of magazines. He works in acrylic and researches his pictures by diving in rivers and lakes. What makes his work distinctive is the use of light, which flickers on the surface of the water (his *Prowling Brookie* is a good example, *see Plate 16*) or sparkles on the droplets falling from a leaping trout (as in his *Broaching Brookie*).

American angling art, though broader based than its British equivalent (its enthusiasm for sea angling would leave most British painters cold) reveals similar underlying tendencies. Artists on both sides of the Atlantic strive increasingly to create the illusion of photographic reality. Thus we find Stanley Meltzoff and Virgil Beck actually joining the subjects of their pictures underwater in order the better to achieve this. As in Britain, style among the angling painters remains doggedly traditional: the attempt always is to make a fish look like a fish. Brushwork is usually smooth and unobtrusive and the artist rarely makes any attempt to draw attention to the fact that his painting is indeed a painting and not merely a representation of something else. That said, however, Americans have broadened the subject range of fish and angling specialists by including sea angling scenes – something almost entirely missing from British art – and the adherence to traditional values reflects the demands of the market.

Arthur Rackham's picture of Isaak Walton, from *The Compleat Angler*.

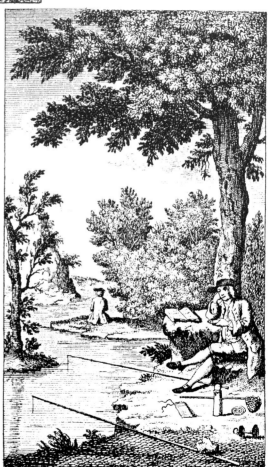

The Compleat Angler: the frontispiece by Moses Browne and Henry Burgh for the seventh edition (*see page 112*).

110

Lord suffer me to catch a fish
So large that even I
When talking of it afterwards
May have no need to lie
ANON

8

THE BOOK ILLUSTRATORS AND COMMERCIAL ARTISTS

Of necessity this can only be a brief look at angling in art as it has developed alongside the growth in angling literature. If horse racing has the best known sporting art, angling most certainly has the best known sporting literature. There can be few people in the educated English speaking world, for example, who have not at least heard of Isaak Walton's *Compleat Angler*.

It is fashionable among some anglers to deride the *Compleat Angler* as an inaccurate ramble, which actually has very little to do with angling. This narrow view is based largely on the fact that Walton is at pains to emphasise the atmosphere, the sights and sounds of angling, rather than the practical aspects. He does include some information about the technical aspects of the sport but these, for the true angler, are of secondary importance. This may be why so many anglers are abandoning the latest space age carbon and boron rods and returning to cane rods and early brass reels, themselves in many cases works of art. If you are interested in efficiency and hi-tech equipment, angling is probably not for you. Walton knew this, which partly explains why his book has lasted so long and been the subject of a large number of illustrators' best attentions.

Walton the man has also been painted, drawn, etched and engraved countless times over the centuries. The best known of these works – the portrait by Husymans and the stained glass window in Winchester Cathedral – represent just the tip of a giant

'Piscator and Venator' and 'Marry, God requite you, Sir, and we will eat it chearfully' from the seventh edition of *The Compleat Angler*.

artistic monument to the world's best known angler. The first edition of Walton's *Compleat Angler* (1653) contained no illustrations as such but almost every edition since has been illustrated.

The seventh edition (1759), has some superb copperplates by Moses Browne and Henry Burgh. These emphasise the quiet, contemplative aspects of the sport by showing anglers frequently in repose. The illustration facing the title page, for example, shows an angler watching his rods from his seat under a tree. His legs are crossed, he is leaning on his elbow (presumably without a care in the world) and he has been reading a book, which lies open at his side. The picture has one or two telltale touches, however. The angler is holding a fish in his hand and although one rod rests idly on the bank some feet away, the other has been very carefully positioned against the angler's leg – presumably so he may pick it up and strike instantly should the need arise.

Another copperplate in the seventh edition shows Piscator and Venator heading

toward a fishing hut which looks more like a Roman temple. On the temple are the words, in Latin, Sacred to Anglers. The emphasis here is surely to suggest that the angler is, above all, a civilised fellow. Other copperplates in this edition illustrate the generosity of the angler (something that is emphasised in the text) and the conviviality and fellowship of the sport.

Dozens of other artists of varying degrees of ability and fame have illustrated the *Compleat Angler* down the centuries, but one of the most interesting was undoubtedly Arthur Rackham. Rackham (1867–1939) studied at the Lambeth School of Art and then worked as a magazine illustrator for twelve years. In 1884 he visited Australia and then, on his return, worked as a book illustrator producing designs for *Grimm's Fairy Tales* and *Gulliver's Travels*. He spent the first thirty years of the twentieth century travelling around Europe, particularly Italy, Germany and Switzerland. During these trips Rackham drew hundreds of watercolour scenes. Towards the end of his life, the publishers Harrap commissioned him to illustrate a new edition of Walton's classic tale and these illustrations are undoubtedly among the very best ever used to illustrate the book. Rackham's *Compleat Angler* pictures, exquisitely drawn in watercolour, are very much in the merry England vein, but they are also curiously brooding: he chooses to illustrate impending storms and threatening gypsies and in this way moves against the prevailing message of the book which is one of peace and calm. Yet this is what gives the illustrations their power.

The success and popularity of Walton's *Compleat Angler* encouraged many other writer anglers to produce books singing the praises of the greatest of all sports and by the end of the eighteenth century there was a positive proliferation of angling texts, both practical and poetical.

Samuel Howitt's *The Angler's Manual* and the seventh edition of Salter's *Practical Treatise* were published in 1808. Howitt's book is unusual in that it was both written and illustrated by him. His etchings are perhaps not the most impressive from the

Arthur Rackham's version of the scene 'Marry, God requite you'.

'Pike fishing' and 'Perch and
Pike', from *The Angler's Manual*,
written and illustrated by
Samuel Howitt, 1808.

point of view of composition, but they are excellent in terms of action and technical
accuracy. Howitt was clearly a skilled and experienced angler as well as a competent
draughtsman and etcher. He was also one of the earliest angling writers to discuss,
as he puts it, 'The management of the hand rod in each method', and he tried to
make his book, and his illustrations, as comprehensive as possible. Thus he drew the
individual species of fish as well as the techniques for catching them: float fishing,
fly fishing, minnow fishing and so on.

The work of Thomas Bewick (1753–1828) represents a milestone in the art of wood
engraving. Bewick, whose father was a Northumberland farmer, was apprenticed in
1767 to a Newcastle engraver, Ralph Beilby. Beilby was one of a number of engravers
working in Newcastle which was a centre for the art at that time. Bewick soon out-

stripped his master in skill and his reputation was high even in his own lifetime. His work attracted the attention of Thomas Carlyle and the great Victorian art critic John Ruskin: both admired his talent greatly. Bewick, who drew a large number of angling wood engravings, was the first great exponent of the white line technique. Before Bewick, wood engravers had cut away the background of their pictures (leaving it white) to produce a raised line which would print black when the engraving was printed. In a remarkable reversal Bewick incised the lines of the image he wanted to produce so that they would not print and would therefore leave a white line. The effect was to create a sense of light that varied according to the form of the objects or figures drawn.

Most of Bewick's engravings were tiny (occupying a few square centimetres only) but they are perfect miniatures. They were cut on extremely hard, end-grain boxwood. Bewick does not merely produce isolated illustrations; in his best work he created a unity in which perspective, background, texture, form, light and shade complement and enhance each other. For the time, the range of his angling illustrations is remarkable. He drew anglers playing fish; tickling trout; watching set lines; wading; tying on new flies; retrieving hooks from branches and falling into rivers.

Engravings by Thomas Bewick.

From *The Compleatest Angling Book that Ever Was Writ*, written and illustrated by Joseph Crawhall.

Copper and steel engravings illustrated many nineteenth-century angling books and in the main these illustrations continued to be relatively undistinguished, but there were exceptions. Joseph Crawhall (whose more famous son is discussed in Chapter 4) produced a most unusual and now very rare angling book which he wrote and illustrated himself. Crawhall (1821–1896) worked for the family ropemaking business in Newcastle and wrote and illustrated books in his spare time. His *The Compleatest Angling Booke that Ever Was Writ* reflects a growing interest among the Victorians in the medieval and the Gothic. His engravings show that if he lacked great talent as an artist he did at least understand angling. And he had a fine sense of humour. His picture of an angler hiding in a river while his tackle is butted skywards by an irate bull touches on a predicament that occasionally crosses every angler's mind.

Perhaps the greatest source of work for the illustrators toward the end of the nineteenth century and into the twentieth was the growing magazine industry. Prominent among those publications which regularly took angling illustrations were *Punch*, *The Illustrated London News* and *The Field*. At one time towards the end of the nineteenth century *The Field* was Britain's biggest selling newspaper and with photography still something of a novelty it, and other papers like it, needed large numbers of illustrations.

Among the artists whose work was often used we find George Denholm Armour, Charles Whymper, Phil May and Lewis Baumer. Many of these magazine illustrations were comic. Armour's life and work are discussed in more detail in Chapter 5. He

AGRICULTURE IN THE HIGHLANDS.

Fisherman. "WHAT ON EARTH DO THEY DO WITH THESE LITTLE PATCHES OF CORN THEY GROW UP HERE?"
Gillie. "WEEL, I'M THENKIN' THEY JUST GROW IT FOR SEED THE NEXT YEAR."

Agriculture in the Highlands by George Denholm Armour from *Punch*, 16 December 1908. The caption reads: *Fisherman.* "What on earth do they do with these little patches of corn they grow up here?" *Gillie.* "Weel, I'm thenkin' they just grow it for the seed next year."

A Phil May drawing from *Punch* 1897. *Lunatic* (*suddenly popping his head over wall*). "What are you doing there?" *Brown.* "Fishing." *Lunatic.* "Caught anything?" *Brown.* "No." *Lunatic.* "How long have you been there?" *Brown.* "Six hours." *Lunatic.* "*Come Inside!*"

Sporting Intelligence by Lewis Baumer, from *Punch*, 1908. *Native (to Sportsman, at close of a blank afternoon).* "I see a tidy gudgeon, about two moile furder down, not more'n a week ago!"

Charles Whymper, *A Ticklish Cast*.

An illustration by H.M. Bateman for *Fly Fishing for Duffers*. 'The Duffer – the man without skill of hand, without good eyesight and no longer young – the man who really ought to fish!'

118

worked as a painter and illustrator and he had a good technical grasp of angling. Charles Whymper (1853–1941) painted landscapes and animals, but he made his living as an illustrator who produced a number of angling pictures for the magazines. He exhibited from 1876 and travelled widely, publishing his *Egyptian Birds* in 1909.

Henry Mayo Bateman (1887–1970) is among the best known of the angler illustrators. Born at Sutton Forest in Australia, Bateman came to England and studied at Westminster and New Cross Art Schools. He contributed a large number of illustrations to magazines like *Tatler*, *Punch*, *Pearson's Weekly* and *The Field*. Bateman, who also wrote a number of books, had his first solo exhibition in London in 1911 at the Brook Street Gallery. Like Phil May, Bateman's illustrations are light, well drawn and, when it comes to angling, entirely convincing. Among his best work are the illustrations he produced for R.D. Peck's delightful *Fly Fishing for Duffers*, first published in 1934.

With one or two notable exceptions there has been a tendency among more recent book publishers to concentrate not on books that emphasise the pleasure and poetry of angling, but rather the technical side of the sport. This produces large numbers of more or less dull books which all seek to explain how, using the latest technology, we can all improve our catches, as if that were the sole purpose of going fishing. The illustrations for these books are, in the main, fairly unimaginative, technical and dull.

A notable exception to this in recent years has been the splendid work of Martin Knowelden for Stephen Downes' *New Compleat Angler*. Knowelden's fine pictures rise far above mere illustration. Among the best are his *Bream Moving Through Gloomy Water*, a marvellous and delicately drawn picture which entirely captures the essence

Illustration of roach by Martin Knowelden,
from *The New Compleat Angler*, 1983.

of the species and its environment. The use of minimal but highly effective light in the picture is particularly striking. But of an equally high standard are his other pictures of pike, still lifes of fish, pictures of boats, tackle, surface feeding carp and fish being played. All are striking, both in terms of their design and execution. Knowelden, who trained at the Watford Art School, specialises in wildlife subjects. He is also a sculptor, woodcarver and falconer who lives in East Anglia. He has had numerous one-man exhibitions in Europe, North America and Britain. *The Times* once described him as 'the greatest living painter of fishes'.

Among the other living illustrator painters of note are Philip Murphy (born 1947) who specialises in river scenes. Among his more recent work was a commissioned set of illustrations for *Tales From the Water's Edge*, a book of interviews with Britain's oldest gillies. Murphy has also completed a series of paintings of scenes along the River Test. Apart from his illustration work Murphy paints landscapes, riverscapes and angling pictures. His watercolours, though very much in the traditional mould, have great delicacy of touch and feeling (*see Plate 16*).

Modern magazine illustrators are few and far between simply because photography has largely taken their place. The 'Mr Crabtree' cartoon series, drawn by Bernard Venables during the 1950s and 60s for the *Daily Mirror* and, later, for *Angling Times* was popular and well, if rather simply, drawn. Venables is also a painter of angling scenes and his coarse fishing scene, *A Weir on the Sussex Ouse near Barcombe Mills*,

Bernard Venables, *A Weir on the Sussex Ouse near Barcombe Mills.*

A postcard illustration by Mabel Lucie Attwell (*left*) and two others of the same period.

takes us back to the traditions of much earlier landscape painting by making the angler a small, yet significant part of the landscape.

Few photographers of angling scenes could be described as artists, but there is one exception: Chris Yates. Yates, a professional photographer is not content simply to photograph a fish or any angling scene. Using techniques of superimposition and with a fine sense of composition and lighting, he has created a number of highly artistic images. As a matter of interest he also happens to hold the record for the biggest coarse fish ever landed on rod and line in Britain: a $51\frac{1}{2}$ lb carp.

Chris Yates works in part at least using his pictures to illustrate his own and others' books. His work has also been used in a number of magazines, but there is nothing obviously commercial about what he does. However, in the twentieth century commercial artists have been quick to see the possibilities, particularly from a humorous point of view, of angling in art.

Postcard manufacturers in the first few decades of the twentieth century produced large numbers of angling images. These were often amusing or absurd, ribald or sentimental in the extreme. The Dundee Company of Raphael Tuck & Sons were responsible for some of the most memorable of these cards. Mabel Lucie Attwell's drawing of a stylised toddler and his dog reveals just how debased the idea of angling and innocence could become, but in spite of its dreadful sentimentality cards like this sold in their tens of thousands. Two other examples of angling postcards *Guid Luck* and *You Can't*

Catch Fish By Swearing at Them give some idea of the kind of humour the cards usually involved, though the latter is at least competently drawn.

The most accomplished book illustrator of the twentieth century from the point of view of angling in art, was Denys Watkins Pitchford (1905–1990), better known as BB. BB was a Royal Academy trained artist who also studied in Paris. He spent most of his life in his home county, Northamptonshire, where he painted and drew the sports he loved: fishing and shooting. BB's biggest contribution to the art of book illustration was his innovative use of scraperboards to create an image that has much of the quality of a fine woodcut. He wrote nearly sixty books during his life and one, *The Confessions of a Carp Fisher*, is considered to be for the twentieth century what Walton's *Compleat Angler* was for the seventeenth. The book is an undoubted classic, largely because it manages to encapsulate the mystery and poetry of angling rather than the practicalities of the thing. But the angling illustrations for this and many other of BB's angling books are of the highest quality.

Book and magazine illustration are difficult both from the artist's point of view and that of the critic, because the artist is obliged often to work to a tight brief and it is therefore only the very best of the illustrators who can, within the commercial constraints imposed, produce something worthy and memorable, but as we have seen over the centuries a few artists have always managed, however great the difficulties, to create images of real and lasting power.

Scraperboard illustration by Denys Watkins Pitchford (BB).

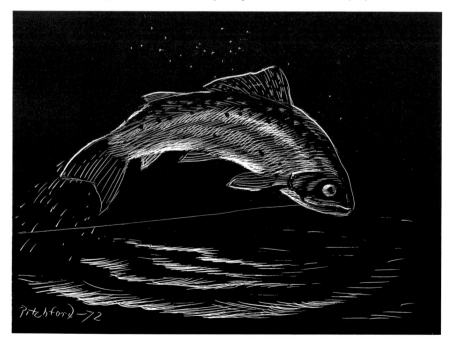

SELECT BIBLIOGRAPHY

Abse, Joan, *The Art Galleries of Britain and Ireland*, Robson Books, 1985.

Adler, Kathleen, *Unknown Impressionists*, Phaidon, 1988.

Briggs, Ernest, *Angling and Art in Scotland*, Longmans, 1908.

Farr, Dennis, *English Art 1870–1940*, Oxford, 1978.

Garrett, Albert, *A History of Wood Engraving*, Bloomsbury, 1978.

Gaunt, William, *A Concise History of English Painting*, Thames & Hudson, 1978.

Hamilton, Vivien, *Joseph Crawhall*, John Murray, 1990.

Herrmann, Luke, *Turner Prints*, Phaidon, 1990.

Hill, David, *Turner's Birds*, Phaidon, 1988.

Humphreys, Richard, *The British Landscape*, Hamlyn, 1990.

Janson, H.W., *A History of Art*, Thames & Hudson, 1985.

Kahn, Gustave, *The Drawings of Georges Seurat*, Dover, 1981.

Kewley, Charles and Howard Farrar, *Fishing Tackle For Collectors*, Sotheby's, 1987.

Lagerlof, Margaretha Rossholm, *Ideal Landscape*, Yale, 1990.

Laird, Marshall, *English Misericords*, John Murray, 1986.

Mills, Derek, *The Fishing Here is Great!*, Collins, 1985.

Pendred, G.L., *An Inventory of British Sporting Art*, Boydell, 1987.

Prown, Jules David, *American Painting*, Macmillan, 1980.

Radcliffe, W., *Fishing from the Earliest Times*, Murray, 1921.

Reynolds, Graham, *Victorian Painting*, Herbert, 1987.

Sanders, N.K., *Prehistoric Art in Europe*, Pelican, 1968.

Shanes, Eric, *Turner's England 1810–1838*, Cassell, 1990.

Spalding, Frances and Judith Collins, *20th Century Painters and Sculptors. Dictionary of British Art, Vol 6*, Antique Collector's Club, 1988.

Sparrow, Walter Shaw, *Angling in British Art*, Lane, 1923.

Taylor, Desmond Shawe, *The Georgians*, Barrie and Jenkins, 1990.

Turner, Graham, *Fishing Tackle, A Collector's Guide*, Ward Lock, 1989.

Walker, Stella, *British Sporting Art in the 20th Century*, The Sportsman's Press, 1989.

Waterhouse, Ellis, *Dictionary of 16th and 17th Century British Painters*, Antique Collector's Club, 1988.

INDEX